OFFICE GIRL

a novel by
JOE MENO

TELEGRAM

OFFICE GIRL.

OR

BOHEMIANS.

OR
YOUNG PEOPLE
ON BICYCLES
DOING TROUBLING
THINGS.

Published 2013 by Telegram

ISBN 978-1-84659-170-9
eISBN 978-1-84659-171-6

First published 2013 in Great Britain by

TELEGRAM
26 Westbourne Grove
London W2 5RH

www.telegrambooks.com

Under license from Akashic Books, New York (www.akashicbooks.com)

A full CIP record for this book is available from the British Library.

Printed and bound by CPI Group (UK) Ltd, Croydon, CR0 4YY

Art does not tolerate Reason.
Albert Camus

No human heart changes half as fast as a city's face.
Charles Baudelaire

Our central idea is the construction of situations, that is to say, the concrete construction of momentary ambiences of life and their transformation into a superior passional quality.
Guy Debord

ODILE

ANYWAY IT'S SNOWING.
But then there is the absolute bullshit of it! The amazing gall of some people! Who does he even think he is? Odile Neff, art-school dropout, age twenty-three, rides her green bicycle along the snowy streets of the city that evening at five p.m., arguing with herself. She is wearing one gray sock and one black sock and her faint-pink underwear, hidden beneath her long gray skirt, is dirty. It is January 1999, one year before the world as everyone knows it is about to end. Communism, like God, is already dead.

Having just finished an eight-hour shift conducting telephone surveys for an international research company— *How many members in your family? What sort of hair spray do you use? How often do you use your hair spray? Have you noticed any dermatological irritations, including but not limited to eczema, carbuncles, warts, or various skin cancers, in connection with the frequent use of your hair spray? Has your hair spray ever interfered with the quality of your life?*—she is now riding home and swearing to herself about something she is having a difficult time understanding, and about the person who has become the cause of all her grief. Her green hood is up, completely covering her small white ears, green scarf bound around her chin, the hem of her gray skirt blowing as she pedals along. It's only the second week of January but the winter has already become a verifiable pain in the neck. She wears her pink mittens which have become unknotted, the pale pink penumbras of her fingernails peeking out. And with these mittens she holds the cold plastic of the bicycle's

handles, cursing to herself again and again.

"Asshole!" she shouts out loud. "Why won't you talk to me? Why not just talk to me and be honest about everything?"

She never thought she would be so stupid, and yet, here she is. Her fancy pearlescent shoes, bought for twelve bucks at the thrift store, keep slipping off the pedals, making her even more frustrated. The gray sky, the waxy unending weather, the caliginous buildings rising up in humorless planes of speckled silver glass, all of it makes her feel so small, so tiny. The snow continues its liberated march in considerable flakes, falling all around in achromatic sheets of bleary chalk. Also, there is his gray sock, Paul's gray sock, sitting in the left pocket of her parka, which she has been carrying around for the last few days.

Why am I so stupid? she asks herself again. *Why do I keep wanting to be with him?*

Her face is an abject expression of disgust, mouth twisted to the side in a frown, narrow eyebrows raised.

Is it just because I'm not supposed to? Is it just because he's married? Is it just because I thought I had the world by the balls and I always end up making a mess of everything?

Her green bicycle, unable to answer, only vibrates with rage.

AT A STOPLIGHT.

Odile pauses a block later at a stoplight which has become obscured by ice. She looks over and sees a bus idling beside the curb. On the side of the bus is an advertisement for some men's hair dye that promises to be *SO FEROCIOUS!* Odile grabs the silver paint marker from the pocket of her green coat and uncaps the pen and leans over and draws a pair of enormous silver breasts on the male model in the advertisement and then adds a pair of hairy, dangling, unkempt testicles between his legs. Beneath this pictogram she writes, *You are an idiot, Paul*. She then caps the pen, shoves it back into her pocket, and rides off through the uninterrupted snow.

A NOSE UNLIKE HER MOTHER'S.

Odile, pronounced *O-deel*, has dark hair, which runs just past her shoulders, a wide forehead, which is framed by uneven bangs she cut herself, and a pair of gray-blue eyes that are set several inches apart in a soft, heart-shaped face. The size of her eyes, larger than most girls', lends a quality of constant amazement to all of her facial expressions. Her ears are attached to her head at a spot lower than average, and are also a little wider, suggesting an elfish affectation, though this is hardly noticeable, as it's her large, gleaming eyes that draw you in. Her nose is neither long nor snub and is rounded in appearance, as it often is on the faces of girls of European descent. Her nose is unlike her mother's, who at first glance may appear to be the greater beauty, as there is a small bump along the left side of the bridge of Odile's nose, imperceptible to anyone who has not spent an afternoon lying in bed beside her, listening to the song she loves the most, "After Hours" by the Velvet Underground, or admiring her profile in the dark of a theater, ignoring the black-and-white film by John Cassavetes. This very small bump is the consequence of an ice-skating accident that occurred when Odile was six, and, on deeper inspection, only adds to her attractiveness. It allows the viewer to wonder what other worlds, what other small pleasures, there are to discover. Like the small beehive tattoo on her left wrist, which is so faint it's almost invisible: What does it mean? How old was she when she got it? Will she tell about it you if you sleep together? You look at it and then up at her open mouth, at the sensitive lips, the lips rounder and

somehow more adventurous than you noticed at first glance, the mouth already smiling, already laughing at something you said or did.

At the moment, atop her bicycle, her mouth is partially occluded by a green scarf, though it's moving as she continues arguing with herself out loud. She curses at a cab driver and swerves past a woman with an incredibly wrinkly face, dressed in a gray fur coat. The woman's arms are piled high with packages, each of them tied nicely with a white string bow. *Your face looks just like an elephant's,* she wants to say but means it in the nicest possible way. And look out: there's another drift.

BUT TEN YEARS BEFORE.

At the age of twelve, two weeks before her thirteenth birthday, Odile was molested by a group of boys who were several years older. It was after ice-skating practice one afternoon: Odile was waiting outside the rec center for her mother to come pick her up in the plain beige station wagon when five young men, boys from the nearby public school, found her sitting on the snow-covered merry-go-round and then began to taunt her. One of them had a ski mask on, another a red scarf around his face. She ignored them at first but when the boy with the mask leaned over and said something dirty, like, "Do you want to take a bite of my dick?" she stood, trying to run back inside the rec center. After a few steps through the snow they chased her over to the bottom of the cold metal slide, and then they took turns holding her down while each of them put their hands all over her, one of them, a boy with a dark peach-fuzz mustache, going so far as to get her black tights down to her knees. Another boy, who had a face like a mussel, all droopy and white and silvered-over with sweat, was the one peering over her when Odile realized it was she who was screaming. And then, somehow, she got her left hand free and grabbed ahold of his right ear and pulled as hard as she could. The boy shouted and rolled off and then one of the other boys hit Odile in the side of the head with a clod of snow and then she just laid there like she had died. The fact that she hadn't died was, in fact, an awful kind of disappointment. She watched through a swollen eye as the boys all walked off. And then she got up a few minutes later and stumbled over to

where her bag was lying, unfamiliar as an amputated limb, and then, holding her sore ear, her sore cheek, she limped to find her mother parked out in front, humming along to Sonny and Cher on the radio. Odile told no one about the incident and instead decided that if such a situation should happen ever again, she would force her attackers to kill her first. Having survived such a particularly violent and thoughtless assault, Odile found she was no longer afraid of anything.

AT THE CORNER OF DAMEN AND AUGUSTA.

On her bicycle, Odile stops at another red light and adds a pair of boobs to a poster advertising some moronic new hip-hop release. The rapper, DJ RAW, with his sunglasses and grill of gold teeth, now has a gratuitous pair of silver saddlebag tits hanging from his chest. And then she adds a diamond over his face. And then sketches a silver dunce cap on his head. This is all she's been doing lately, drawing on street posters or other advertisements, because she hasn't made anything good, anything really interesting of her own, in weeks. Lately all she's been making are these weird, lewd doodles which she can't even call art. She places the cap over the paint marker and then glances over at a blue newspaper dispenser which features a headline having to do with the president getting impeached. The idea of being impeached for getting a bj makes Odile crazy. Maybe in the next millennium people won't be so worked up about screwing. Maybe after the comet that is coming to wipe out the world on New Year's Eve has already annihilated everything, and people have become wax-faced mutants, maybe then everyone won't be so uptight about sex. Maybe. And thinking of this, she adds a hairy vagina to the poster DJ's lap. Yikes, it looks like a black insect. And she does all of this before the light turns green.

BUT THEN THERE IS HER YOUNGER BROTHER.

And she rides up to the shadow of her apartment building and locks her bicycle to the iron gate out front. She climbs the wet carpeted stairs and hopes her kid brother will be gone, but when she unlocks the door, she sees him still lying there on the couch, still wrapped up in his green sleeping bag, his dark brown bangs hanging in his too-skinny face. He doesn't look right anymore. He looks a little disturbed, a little too serious for a boy who's only seventeen.

"What are you still doing here, dipshit?" she asks. "You said you were leaving this morning."

"I know, but then an episode of *CHiPs* came on, and I couldn't make myself go."

"You need to leave, Ike. You can't stay here. Mom and Dad are already going absolutely nuts. They called last night. They're really super-pissed. At both of us. But mostly me. You said you were going to the bus station this morning before I left."

"I know," he says, nodding his head. "But I don't want to go back alone."

"You only have one year left. When you're done, then you can come live here."

"But I hate it. I hate Minneapolis. I hate my friends. I hate having to live with Mom and Dad all by myself."

"Why? They don't ever fight. They're the greatest parents in the world."

"That's what I mean. They're always trying to get me to watch TV with them. They asked if I wanted to go to a movie

with them a few weeks ago. It's too much. They just won't leave me alone. They're way too supportive. It practically borders on abuse."

"Okay, come on," she says, standing before him. "Pack your bags. We're going to the bus station right now."

"Really?"

"Really."

And he nods and sits up and begins to fold his green sleeping bag.

And then they are walking back into the snow, Odile unlocking her bicycle, pushing it beside them, advancing step by step through the ever-increasing drifts, her brother, six years younger, though already taller than her by several inches, shuffling alongside her, their frames, the shape of their shoulders identical, their hair color exactly the same, their mannerisms mostly different, though in their expressions there is a similar aloof candor, the same sense of amusement at most things. And it's snowing around them and all of a sudden Odile remembers what it was like to be a kid, and to have played in the snow with her little brother, and for no other reason she turns and shoves Ike into a pile of it. And then she hops onto her bike and tries to pedal off. And so begins the now-famous chase sequence that ends only at the turnstiles of the Blue Line station on Damen Avenue.

AT THE GREYHOUND BUS STATION.

And on together riding the Blue Line subway to the Greyhound station downtown, and then afterward, Odile sits beside her younger brother in the hard vinyl chairs, ruffling his shaggy, dark hair. She looks at him and is surprised again at how skinny his face is. She kicks her legs back and forth, glancing up at the institutional-looking clock every so often.

"How long is the bus ride again?" she asks.

"About ten hours."

"That's a long time."

"I don't care. I have a book," he says.

"What's the book?"

"It's some fantasy series I'm rereading."

"So have you thought about what you're going to tell Mom and Dad?"

"No, I'll just say what you said."

"What was that?"

"That I had a freak-out. And that high school isn't the way they remember it. And I didn't want to take that Spanish test."

"That's good," she says, smiling. "You know, if you ever get into any real kind of trouble, you can always count on me."

"I know. That's why I came."

"But you're not in any real trouble."

"I know," he says. "But I missed you."

And then Odile smiles, the dimple appearing on her left cheek.

28

"I was hoping maybe you'd come back with me," he continues. "It's not as fun there anymore. I don't have anyone but Mom and Dad."

"I have a life here, kiddo," she says. "This is where I live."

"I know, but what's so great about this place? It's pretty dingy-looking."

"I don't know."

"Is it the buildings?" he asks.

"No."

"Is it the people?"

"No."

"Are you in love with someone here?"

And she shakes her head and knows her cheeks are glowing red. "How about this?" she asks. "You can come visit any time you like. As long as you call me beforehand."

"Okay. Okay. Sorry about getting you in trouble with Mom and Dad. I'll call next time and tell you I'm coming."

"Great," she says, and then the static-filled announcement blares over the wires and Odile stands, helping her brother with his backpack and sleeping bag. And he hugs her and begins walking away, his gait slow but more confident than you might guess.

"You're gonna be all right!" she shouts, folding her hands together like a megaphone. "Better than all right. I see big things for you, kid. Big things!" and he shakes his head and gets a little red too, and he waves to her and walks away. And then she begins to think maybe he is right. What's so great about this city? What's so great about Chicago? On the ride home, her bicycle rattling beneath her, she thinks, *Nothing*. And if she had climbed on that bus with her brother, would anyone have noticed? Probably not. Because Jeannie called from New York only yesterday and told her she had a place where Odile could crash, at least for a few months.

And because Odile's lease is up at the end of February, she's thinking maybe she should go. Because if not now, when? And as she rides she hums a song from the band Half Japanese, considering all these different possibilities. And so.

MEN WHO HAVE ACCUMULATED AROUND HER.

1. Reginald, her former English teacher, who chaperoned the Literature Club when Odile was in high school, and who was responsible for her *Franny and Zooey* phase. Even five years later, few days pass that Reginald doesn't stare at the blossom-faced female students in his English class, wishing they were more like Odile, punishing them with surprise quiz after surprise quiz because they are not.

2. A boy who she held hands with at the mall just outside Minneapolis when she was seventeen. This young man, Max, still walks by the video arcade every few weeks, and sighs, thinking of the afternoon they spent playing game after game of Miss Pac-Man.

3. Brandon, the first adult relationship she ever had, during her freshman year in art school, and who was the first boy she ever cheated on. A red flame of sadness still crosses his face whenever he thinks of her.

4. Will, an art student pursuing photography, who once talked Odile into doing some racy Polaroids. There are seven of them. These seven Polaroids are still kept at the top of Will's sock drawer. He will sometimes flip through them to masturbate, but also, sometimes, simply to see the daring look of abandon, the recklessness glowing pink there on her face.

5. Paul, who is not an ex or even a boyfriend, but who is someone she is afraid she has fallen in love with.

BACK AT HER APARTMENT.

And so she lugs her bicycle up the stairs and begins to frown even wider as soon as she sees a pair of men's tennis shoes lying at the front door. Because there are her roommate Isobel's orange high heels left in an awkward pattern beside them. And there is some bad music coming from inside. And Odile opens the apartment door and finds Isobel and her boyfriend Edward making another stupid art movie. Edward is in film school. And Isobel just so happens to be an exhibitionist, and she has hung dozens of near-nude black-and-white photos of herself all around the apartment. At the moment, Edward is dressed like Darth Vader, wearing a black plastic mask, and also a pair of white underpants. That is all. Isobel is in her underwear too, which is an alluring shade of pale green. She is topless and is wearing a Storm Trooper helmet. Together they sit on the couch, tickling each other and laughing. Edward is trying to hold the video camera up while wearing the awkward-looking black mask. "I'm going to fuck you using the Force. I am. I'm going to do it." This is their idea of art, of becoming famous. Odile coughs once, closing the front door behind her. The couple turns and regards her in absolute silence. Odile nods at them and then carries her bicycle inside, feeling embarrassed for everyone present. As soon as she closes her bedroom door, Isobel and Edward immediately begin laughing. Darth Vader begins breathing heavily once again.

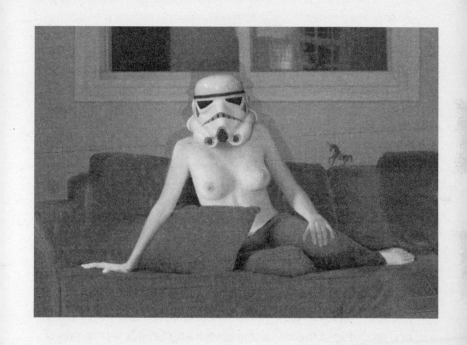

And so Odile sits in her room, with her hands over her ears. It gets very quiet all of a sudden and she can tell Isobel and Edward are trying not to make a sound, which is worse really, because the absence of noise makes Odile more aware of what they're doing. And she can hear the slightest laughter, the smallest giggle, the sound of the sofa rocking a little, and Isobel muttering a pleased sigh, and for some reason Odile decides not to fight it, and climbs under her covers and fits her hand between her thighs. And she closes her eyes and thinks of Paul and then no one really at all, someone totally faceless, and she is rocking her hips back and forth and then she hears Isobel make another soft sound and Odile opens her eyes and feels ridiculous for what it is she's doing. She pulls the blue blanket over her head and shouts, "You are so stupid!"

And then she leans over and searches blindly beneath the bed frame for a certain comic book: *Abstract Adventures in Weirdo World* is what it says on the title page. It's from some other era, somewhere in the early '70s, something she bought at a garage sale a few weeks back. The artwork is crude and the story line almost meaningless but she thumbs through it anyway, studying each panel, each line. On one page there is a pair of lips chasing a mustache and on the facing page, an explicit orgy of dogs and cats. *Why doesn't anyone make anything weird like this anymore?* she thinks.

Before long the moans begins to eke out again and so Odile throws down the comic book and pushes herself out of bed. She begins searching through the ominous-looking piles of clothes on the ground and finds a T-shirt for a band named Suicide. She sniffs it to see if it is dirty. It's okay. She pulls it on and then begins to gather up all the clothes on the floor. The wall beside her continues to thump, once, twice, then a third time, all with an unbearable urgency. Odile starts to shout again, banging on the door. She finishes collecting

her laundry, forces it all into a paper shopping bag, and then storms out of the apartment. The Laundromat is a block away and she can kill an hour or so there. Which she does, but unhappily.

AND THAT NIGHT GOES TO AN ART OPENING.

It's her friend Liz's opening, and all of the art looks like it's been done by deranged teenage boys, like it's part of some gigantic game of Dungeons & Dragons, or else it's been inspired by anime or video games; it's full of weird purple tentacles and vaginas with teeth, and all of it is lacking any kind of originality, none of it does anything for her, and so she drinks. She gets seriously drunk. She puts away four small plastic cups of red wine and then stares at a painting of a topless girl with a large silver sword for a half hour and then she begins to think: *You call this art? This isn't art! This is a joke! All of you are a joke! Fuck you and fuck Jeff Koons and all the rest of those '80s art-star wannabes. Where's the art that makes people weep? Where's the art that makes people want to go to church? None of this is the least bit interesting. All of this stuff, all of this is so self-aware. It's all art for ironic art snobs. I want something brilliant. I want something stunning. I want something that makes me look in wonder,* and as she stumbles from painting to painting, she trips over her own rubber snow boots and spills her wine and her friend Liz, her freckles going bright red, helps her to her feet and then back outside, where Odile finds her bicycle crowded with three or four gray pigeons. "Shoo," she says, but the pigeons don't want to move.

AND THE NEXT DAY AT WORK.

Odile yawns on the telephone and enters the appropriate answers into the appropriate fields on the computer and then it is almost eleven a.m., which is when she likes to walk by the supply closet to steal something: anything. It's the only thing that makes her feel the least bit alive at her job, taking things, and she usually prefers snatching the small bottles of liquid paper to sniff discreetly at her desk. Or a box of pastel Post-it notes which she uses to cover the rat holes in her bedroom wall in various odd geometric patterns. Or the small colored notebooks to do sketches and write her ideas in. And so today she stands, straightening out the bell shape of her skirt, and treads the worn-out carpeting down the aisle past Paul's office, which is indicated by a hand-drawn sign he had to make himself, *Asistant Manager*, the word *Asistant* misspelled. She goes to the supply closet and takes a brand-new green notebook and slips it in her pocket. And on the way back, she sees Paul talking to a girl by the broken-down copier, and the girl's one of the other girls who does phone surveys, and she looks like she was probably vice president of her sorority back in Ohio or some such shit, because she has red hair not found in nature and a great-looking ruffled blouse and they are standing beside each other at the oldest copy machine in the world, which gets ink all over everything, and both of them are laughing at a copy that looks like a Rorschach test moth but laughing in a way that immediately reveals something else is going on because no one really laughs like that unless you are in love, or at least fucking, because Paul is slightly handsome,

with his soft brown hair and very small eyes, but he is not at all funny, and Odile's face goes red and she hurries past and rushes into the bathroom to hide in the farthest stall, and then, on her way back, she passes the girl Jennifer's cubicle, and she looks right at Jennifer and asks, "Are you doing it with Paul?" and the girl, who Odile sees is probably older than she is, just smiles without smiling and says, "Why do you care?" and Odile shouts, "Why do I care? Are you kidding me?" and she begins to blush and hurries away, back to her boring cubicle. And she spends the rest of the day typing the letters F-U-C-K-T-H-I-S on her computer screen again and again.

And this is what makes her so mad as she's riding home from work that night. The realization that, after all, she knows she is nothing special, not to anyone but herself, and does that even count? Not very likely.

Why did she think this city would be different than Minneapolis?

Because it isn't. It's only bigger. And a whole lot noisier. If anything, this city's only made things harder for her. Because just look at the kind of person she's becoming. One of those girls who will give a handjob to just about anyone. And this, Paul, this is exactly the kind of thing that happens when you fall in love with someone you shouldn't.

On she rides, still mumbling to herself beneath her green scarf, thinking of all the other things she does not like, and so this is what she mutters out loud:

ODILE MONOLOGUE TO SELF.

"I do not like beards on men. Or ironic mustaches. I do not like kissing someone and seeing a bunch of marks all over my face because they don't know how to shave. I don't like men with big hands. Or small hands. Or hands that are sweaty. I don't like men who wear the color red. I don't like the color red. Red is for assholes. I don't like music you can high-five to. I don't like high-fives. Or the act of high-fiving. I don't like the look people get on their faces when they high-five each other. I don't like the size of my breasts, which are almost nonexistent. I do not like my butt either, which is too flat. Or my hair, which I've dyed too many times and now is brown and shoulder-length but brittle. The bangs are okay because I cut them myself except now I look like some kind of flapper.

"I don't like the fact that no one has any imagination anymore. It doesn't pay to be a dreamer because all they really want you to do is answer the phone. Nobody wants you to think about anything new or use your brain or make anything interesting because everything important has already been made. America is over; it's done being brilliant. Just like all the factories near the river, which are closed-up and empty. Everything genius has already been built, like all the great works of art have already been produced. Also, whenever I tried to do anything imaginative in my classes at art school, all the teachers looked at me like I was a nut. Like the time I made the dress out of chewing gum. Actually, I never learned anything of the slightest importance in art school. I only have two semesters left and I doubt I'll go back now, because what's the point? It

doesn't seem like any of it matters. Besides, I haven't made anything interesting in a long time and now I'm working so much that it's hard to give a shit about going back to school.

"Then there's the fact that I do not know if I have what it takes to be an artist, because the kind of things I like to make don't seem to go over with anyone. Like paintings of igloos having sex. And genitals on fruit. Because I don't give a shit about taking myself so seriously, but apparently, that's all my teachers really wanted me to do. Apparently, everyone was supposed to make a painting about war and the failure of God and female genital mutilation at some point. But really, I didn't want to. It doesn't take any kind of artist to make art about what already exists. Or that's the way I think anyway. Any idiot could do something like that. What I want to make are things that you have to imagine, things that are slightly impossible, but then you have people like Professor Wills who taught my Painting Four class and who said my work was 'twee' and 'whimsical,' which really meant 'weak.' And what were the other people in class painting? Still lifes of vases and flowers. Which is the real reason I think I quit art school. Because no one had any imagination. That and the fact that I couldn't really afford it. And how many people become artists out of art school? It's all pretty ridiculous if you think about it.

"I'm better off working a job anyway. The job at the survey office is not so bad and even though it's a bore, I know I'm lucky to have any kind of job right now, even though it's pretty mind-numbing. But it's still better than my roommate Isobel who works at a corporate copy shop making copies for people who can't figure out how to use a copier themselves. At least, with the survey job, I don't have to deal with absolute idiots. There are just a high percentage of people who are incredibly old, because those are the only people who answer their phones anymore, and then there is the fact that I've

fallen in love with someone who happens to be my supervisor, and I've only slept with him three times, and two of those times I only gave him a handjob, which hardly even counts, but apparently it doesn't mean that much to Paul either because he's obviously seeing other girls in the office. Which is retarded. Because the more I think about him, the more I realize I really like him.

"Paul is probably the first person I actually enjoy having sex with, because he's a couple years older and totally unapologetic, while the other four people I've slept with always wanted to talk about everything beforehand, and during, and even after. I lost my virginity back in high school, when I was a senior, working on the school yearbook. It was with a boy I did not like but I knew he was smart and I thought I could trust him. It was more like a social experiment than actual sex, at least to me. We only did it twice because he had a girlfriend who was away at college, and he never mentioned it to anyone, and I think I will always be thankful to him for that. The first time we did it he came on my skirt and I didn't know what to do so I just laid there. For like a half hour. Seriously. Anyway, he used to kiss too hard. He kissed like that because he watched too many porno movies, I think. And then there was Brandon, who I dated freshman year, and a boy I met a party who I never saw again, and then this other guy, Will, who I was seeing off and on for a while—a photographer who I met in art school, who doesn't even actually take pictures anymore because he's a waiter right now—and once he wrote me this long letter asking why I didn't make any sounds during sex and I happen to think it's more sexy if you are quiet and he said I needed to start acting like I was having fun with him in bed, so I decided right then it was probably not going to work because what I've figured out is that it never gets any easier once you fall in love with somebody. Even with Paul."

Odile pauses at a stoplight on Orleans, just after the bridge. The snow comes down like a bad feeling.

She looks up, catching a single snowflake on the tip of her pink mitten. The snowflake is lopsided and quickly melts.

She glances around and watches the city fall off into darkness.

You murderous city.

You oafish palace.

I'd like to burn it all down.

What am I doing here? What am I even doing?

What do you do with the rest of your life when you realize you don't like anything?

She decides the only thing to do now is quit.

Okay. She will quit. It will be easy.

Because Odile has quit seventeen jobs in the last three years already.

ORTHOPEDIC SUPPLY COMPANY.
Four days later Odile looks in the ads and takes a job as a third-shift phone operator at a small orthopedic supply company. Apparently, phone operators are on call twenty-four hours a day to attract every possible orthopedic customer available. All Odile does is answer the phone and take down the orders for inserts, braces, slings, and crutches, and talk to podiatrists and orthopedic surgeons from Dallas to Cleveland, answering questions like, "Do you have splints for small children?" She enters the customer's name and credit card number into the computer, and then files her nails, or plays solitaire, or draws dirty pictures on the scraps of paper in the corner of her desk. With her pink ruffled blouse on, the one she found at the other thrift store, the blouse which she sewed back together herself, Odile stares down at her uneven cuticles, talking to an podiatrist from Peru, Illinois. It is one a.m. and he is restocking all of his supplies and is being very thorough about it. The orthopedic supply company plays instrumental melodies over its intercom system throughout the night, and Odile, unconsciously tapping her foot along, is surprised by how many of these songs she actually knows. She takes off her shoes, placing them side by side beneath her desk, and leans back in the chair, entering the podiatrist's order, trying to decipher the instrumental music overhead. "Barry Manilow," she says to herself a number of times each night, without humor.

THERE IS A BROOM CLOSET.

Because of her new job answering telephones at night, Odile stops sleeping normal hours. And because she is not sleeping normal hours, she begins to make a number of questionable decisions. For example: in her second week answering phones, Pete, another operator, who has shaggy brown hair, asks if Odile smokes, and she says sometimes. She thinks he means cigarettes but when she follows him out of the office into the hallway, then down the hall to a broom closet that is unlocked, he takes out a small, tightly wound joint, and she sees he means pot. Now what? She used to smoke pot when she was in high school but she started getting very paranoid and she was always afraid someone she loved, like her mom or one of her brothers, was going to get in a horrible accident and she was going to be too stoned to know how to help, and so she stopped smoking dope when she got to art school because her mom and brothers were so far away, but here is this guy—who is maybe, what, twenty-four, twenty-five?— and his smile is kind of dopey but cute, and they are sharing the joint and then they start making out a little and she knows he's not the one she wants, that the one she wants is already married. But this is a little like real life too, isn't it? and she's feeling slightly stoned and so she opens her mouth, taking her gum out, and sticks it to the side of the closet door. And they start kissing again, which isn't all that bad. At first.

But then Pete puts his hand on her hips, then on her shoulders, then up the back of her blouse, and there is a mop and a broom and a dustpan on a long handle that are all poking

Odile's neck but Pete does not seem to notice, because he is whispering nothings in her ear like, "You're so hot. This is great. I mean, you're a great kisser."

Odile is pretty sure nothing in the broom closet is all that great. The muzak, blaring over the office speakers from down the hall, sounds like real music being held underwater against its will. It is an instrumental version of a Carpenters song. Pete, his face throbbing red, has gone quiet finally. He has his pants unzipped, and what does he expect her to do now?

He looks down and then she looks down and she rolls her eyes a little.

"What?" he asks.

"What are you doing?" she asks.

"Nothing. I just thought ... you know ..."

Odile sighs a little. "I'll give you a handjob but that's it."

Pete silently weighs his options and then agrees.

Odile sighs again and does not know why she goes through with it. But she does. This young man, Pete, has the ugliest penis she has ever seen. It is hairy and misshapen and all out of proportion—the head of his dick looks like it has its own facial features or something. Like it's the face of an old man or a cartoon turtle who slurps soup. And it keeps winking at her. It's disgusting, but she does it, tugging away, looking at the side of Pete's sweaty face. The expression Pete makes when he climaxes is the worst thing ever: like something from a '70s porno movie, or like a clown, gagging, his mouth open, eyes rolled back into his head. She thinks she should do a series of paintings all about the stupid faces guys make when they come. Pete's face is totally ridiculous and she's pretty stoned and she can't help herself from laughing and then she does but realizes too late that Pete does not think it is so very funny.

AND AFTERWARD.

Pete dares to act like he does not know her and even ignores her when she tries to smile at him from across the aisle between the cubicles. There are only three other operators on at this time of night and what does he even care? But he won't look at her and smile back, so screw it. People are just one big useless hassle.

And so night after night, for another full week, she answers the telephone, which never stops ringing. And as she enters an order from Akron, Ohio—a podiatrist who needs a new set of crutches for a patient—she thinks, *I don't even like that guy Pete. Why do I keep doing things with people I don't even like?*

And then it hits her. The podiatrist is asking how they can bill the patient's insurance company and Odile is saying something in response but really she is thinking that she cares too much about what other people think. In fact, she will go so far as to give some guy she barely knows a handjob just so he'll act as if he likes her, which is really no way to get through the world.

When she looks up—another operator, a pimply, hyena-faced squirt by the name of Kurt, winks at her. She is momentarily appalled and then turns, peering over at Pete, who refuses to make eye contact with her. Kurt is now opening and closing his mouth, making little kissy sounds. Odile can feel her face go bright red. Kurt is jerking his hand up and down in the universal gesture for "handjob" and then Odile is standing, and then her face is going red, and then she is trying to run out but trips over the cord for the copy machine, and

she falls against a cubicle, hitting her head, and everyone is staring, until she can grab her green parka and hurry through the glass office door.

Now what?

It's almost one a.m. and the city doesn't even look the same.

She decides she has had enough of that job, of those particular people, and so she unlocks her bicycle and does not bother to let them know she has quit. And then she rides off. And the city is awful, there's never anything pretty, even with all this snow.

AND THE NEXT DAY SHE GETS A TELEPHONE CALL. From the guy she had been seeing a few months ago, Will, who says he's been trying to get in touch and he explains how he'd like his pink T-shirt back. And so she says okay and he comes on over. Will's gotten a goofy haircut, it's longer in the back, and he's growing one of those stupid ironic artist beards but he still looks pretty decent. And so she smiles and hands him his pink T-shirt, the one she stole from him, the one he made that says, *I Love Soft Rock*. It still smells exactly like him, like cigarettes and generic underarm deodorant. And also his dandruff shampoo, which she happens to know is what he uses for soap.

"So how have you been?" he asks, and all of a sudden she sees what this is.

"Did you come over here for your shirt or because you wanted to talk?"

"Neither," he says defensively. "Both. I just thought I'd stop by and see you. Or is that against the law?"

"It's not against the law," she says, still suspicious.

"How's life?"

"That's the stupidest question I've ever heard."

"Sorry." He smiles a little and then squints at her and asks, "So what have you been doing?"

"I've been thinking of starting my own art movement."

"Really."

"It's against anything popular. Even popular art."

"Wow. That sounds great."

"You are so full of it," she says, even though both of them are smiling.

"So are you still the world's worst dancer?" he asks, and she laughs because it's such a bold, ridiculous question, because he knows she thinks she is the best dancer of all time and she has no choice but to roll her eyes at him and then he walks over to the stereo and puts on a CD he brought and then puts his hands around her waist and they begin dancing and she asks, "Who is this?" and he says, "The Police," and they dance some more, and it's become an impromptu dance contest, and Will is a pretty decent dancer and he puts his mouth beside her ear and asks, "Are you still quiet in bed?" and then they are lying in her bed, and he is taking off her sweater and then pulling down her jeans, and she is not stopping him, and she can feel his stupid blond beard against her cheek and his hand making its way down the front of her underwear and she thinks, *I wish the two of us could just go to sleep,* and so she closes her eyes and begins to dream she is in some other place, some imaginary city, farther and farther and farther away from the hands and lips and faces of all other people. And, in the dark, the condom he puts on is pink.

AND IT'S THE DAY AFTER THAT.

And Odile finds out that her roommate Isobel has to get another abortion. It's the second time it's happened. Isobel comes in and sits down on Odile's bed. Both of them are still in their striped pajamas, and together they stare down at the small white pregnancy test. There is something subtly terrifying about the pregnancy test's impersonal mechanical shape and Odile can't stop looking at it.

"Shit, shit, shit, shit, shit," is all Isobel can manage to say.

"Are you sure you did it right?" Odile asks.

Isobel nods. Her face is wet with tears. Even now, even crying, Odile knows her roommate is probably a lot prettier.

"What are you going to do?"

"I don't know. I just called the clinic. It's two hundred and fifty dollars," Isobel says. "I already made the appointment. It's in three weeks. But I don't have any money."

"Did you tell Edward yet?"

"Not yet. He's going to flip. I don't know what we're going to do. Neither one of us has any cash. He's not even working right now. He's just going to school."

Odile makes a sound then that's somewhere between a yawn and a sigh.

"Do you think you could ask your parents for it?" Isobel asks.

Odile feels her face get red. "What? I couldn't. They already ... I just can't."

Isobel nods. "Well, there's no way I'm telling my folks. They took care of the last one. I'm really screwed."

Odile stands, walks across the room, and opens up a small white jewelry box. Inside the box is a mood ring, some jelly bracelets, a terrible necklace her ex-boyfriend Brandon once gave her that he got out of a toy machine at a supermarket, that's shaped like a poodle, and two hundred and thirty-two dollars in wadded-up cash—it's her part of the rent. And she counts the money, then again, and even though she doesn't want to, she hands it over to Isobel.

"I don't want you to have to worry about this," Odile says. "But I don't want to have to go with you again. To the appointment, I mean. I just can't. It was too weird last time."

"Okay, I'll get Edward to." Isobel stands to hug her. It is the first time they have hugged in a long time. Odile thinks it feels good. Isobel's shoulders are firm and bony. "I'll pay this back as soon as I can," she says.

Odile nods and watches her hurry out of the room. She hates how easy everything always is for Isobel, even something awful like this. She knows she is never going to see that money again, so why did she do it?

And now she doesn't have enough for rent, and now she doesn't even have a job. And she is thinking about maybe moving back to Minneapolis or going out to New York, but she's still on the lease here for one more month and even if she wanted to move now, she hasn't got the money for it. And what is she going to do now? What would anyone do?

MUZAK SUPPLY COMPANY.

One of the first want-ads Odile sees is for a phone operator at Muzak Situations. Apparently it's where dentists and insurance agents get their waiting room music, the kind of music that's advertised on late-night television. It's only a temporary job but promises to pay well. The ad stipulates that all potential applicants must have some customer service skills and a college degree. Why would someone need a college degree to answer the telephone? She does not have an actual college degree but the pay looks pretty decent and the fact that it is another night job seems like a good idea, because she and Isobel always get on each other's nerves.

"Do you have any experience with customer service?" the interviewer, a nervous, overweight man with a droopy mustache, asks. The office is ramshackle, there are unpacked boxes everywhere, and it looks like what's going on is slightly illegal. One of the lights in the small conference room keeps cutting out. And the interviewer is particularly sweaty.

Odile looks across the faux-wood desk and nods. "Yes, I worked for a place in St. Paul for two years and that's all I did. This last place, here, was telephone surveys. And then the other one," she points at the line on her resume that mentions her short stint at the orthopedic company and the interviewer nods and asks, "Do you have a college degree or are you still in school?" and Odile asks, "Why?"

"Because people who go to college are responsible. And they don't turn out to be trouble."

Odile frowns, biting the corner of her mouth, and then lies,

saying, "I'm finishing up right now, but don't worry, it won't interfere with work," and the interviewer does not ask her to prove it. He hands her a sample script to take home to memorize and, moments later, the job is hers.

You: Good evening, this is _____ with Muzak Situations. Thanks for calling. What can I help you with tonight?
Caller: I'm interested in your Moonlight and Love *two-CD set.*
You: Wonderful. That's one of my favorites. Are you a fan of instrumental music?
Caller: Yes, I am.
You: I am too. Did you know we also offer a four-CD set of contemporary romance hits which I am able to offer to you as part of our special qualifying period for being a new customer?
Caller: Tell me more.
You: It's called Modern Magic *and it has some of today's most romantic hits by some of the world's best contemporary instrumental artists. It's perfect for any home, office, or medical setting.*
Caller: Thanks, but I'm not interested.
You: I can tell you're having a hard time trying to decide. You can try out any one of our CD sets for thirty days and send it back postage paid if you decide that it's not the best instrumental music you've ever heard.
Caller: Wow, that sounds great.
You: I thought you'd be interested. Now if I could just get your name, address, and credit card information ...

HELLO PAUL.

Odile rides her bicycle through the evening, right in the middle of the gruesome glare of the stalled traffic, happy for the first time in a long while. She wants to call someone to tell them about her new job but does not know who would be happy for her, other than her mother, and she doesn't want to tell her she has a new job because that will only make her worry and so she is stopping beside a phone booth and dialing Paul's number, and later, if she doesn't say anything stupid, they will meet and kiss In the backseat of a taxi and she will know even then that these moments, his gray scarf scratching her bare neck, his hands on the rumpled shoulders of her green coat, the taste of his mentholated aftershave on his throat, these moments are over before they even begin. And although she does not want to, she dials his number anyway, because in those frightful seconds, the city is just too big and too full of people to be alone.

Hello, she says, once the individual sound of the numbers being dialed are done beeping. Paul? Are you there? Paul, are you there?

JACK

THOUGH IT'S SNOWING AT TEN SECONDS
AFTER EIGHT A.M.

On that Monday at the end of January, Jack Blevins, a questionable young man of twenty-five, rides his blue bicycle beneath the flurry, with tape recorder in hand. The snow falls in dark wet flakes across his eyelashes as he listens for something interesting to record. But today there's nothing. The buildings downtown have become a soft white blur while the rest of the city has gone silent. At the moment Jack is wearing his frayed blue winter hat, pulled tightly over his ears, the ball at the top bouncing back and forth; also the amateurishly repaired black plastic glasses which have been taped in two spots and are now fogged up with frost—the prescription for the glasses several years out of date—a gray winter jacket, and a red scarf which is fitted firmly over his nose and mouth. Beneath the gray coat is a black tie and a white dress shirt that's two sizes too small. In his left hand, which is covered in a threadbare black glove, he holds the handlebars and does his best to steer the blue ten-speed through the snow; in his right hand, he holds the silver tape recorder, daring to record anything beautiful—the pneumatic hush of the chrome bus doors as they whisper shut, a murmuration of pigeons swooping overhead, the squeak of a wisecracking child walking along in green rubber boots. It's still dark out, the sun reluctant to rise. Did he shave today? No. He did not. And his brown hair is falling in his eyes. And then he runs into a girl he knows—waiting at a bus stop on the corner of Damen, reading some French novel—and does what he has to to ignore her.

BECAUSE TODAY HE DOESN'T WANT TO TALK TO ANYONE.

He doesn't want to have to explain to anyone about Elise and so he pedals on before the artless, shifting crowd of commuters downtown, all of the other office workers huddled beneath their unwound scarves and bulky winter coats, and then he circles around to record the sound of a pink balloon disappearing above an electronics store and almost falls off his bicycle doing it. People stare at him, wondering what it is he thinks he's doing, watching him hold out the silver tape recorder, slush spinning from the bicycle chain, darkening the bottom of his gray corduroy pants. Ten seconds of the balloon hovering there and he says "A pink balloon" into the small circular microphone and then rides on.

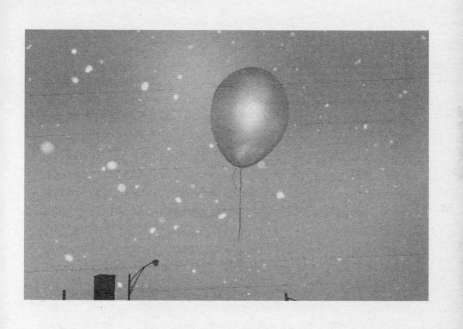

THE ASYMMETRY OF ADULTHOOD.

At an earlier, perhaps less pathetic time in his life, Jack had been recognized as a boy who was terribly handsome, with a swath of dark hair sticking up along the back of his head, an expressive mouth with lips that were flattering but drew no attention to themselves, handsomely proportional ears, a nose that was neither snub nor Roman, and curious gray-green eyes, which no one else in the family possessed. But now, at the ripe old age of twenty-five, in the first flush of adulthood, a decided awkwardness has crept into the lines of his cheeks and forehead, and overall, the feeling one gets when looking into his face is that of an unquestionable anxiety. There is nothing the least bit remarkable about him; everything, including his facial features, is completely, hopelessly average. Watching him ride through the early-morning traffic, it's as if this young man had not so long ago entered an age of dreaminess and confusion, and the features of his face only recently rearranged themselves to match. What is he doing with himself? Where is he headed in life? When, if ever, is he going to do something great? Is this, his average face, his lack of ambition, the reason Elise is going to Germany? He checks his calculator watch and sees he is going to be late again.

BECAUSE AT THIS POINT IN LIFE JACK IS KNOWN FOR ONLY ONE THING.

Jack is famous for having taken his testicles out at last month's holiday party—taking his testicles out of his pants and putting them on the punch ladle, and then walking around the frolicking office, offering his testicles with the ladle, and pretending like nothing was the matter. There are now several descriptions of this incident in his personnel file. Although he was severely reprimanded the next day at the office, Jack did not feel bad. To be honest, this is what Jack has always done whenever he gets drunk. Ever since high school, even on the tennis team. When he drinks too much, he ends up taking his testicles out, which he knows is inappropriate and weird but always ends up happening.

Maybe, he thinks, as he's riding on through the snow, *maybe this is why she's leaving. Maybe she fell in love with me when we were kids. And now: and now: and now: we're not kids anymore.*

AT THE EIGHT-THIRTY A.M. MEETING.

It's impossible to pay attention. Jack works in the production department of a medical advertising firm. It is not rewarding work. What he does is help sell drugs and medical products to people who sometimes do not need them, in advertisements like *Prozac, Live Life Again* and *Your Replacement Hip Could Be Better,* by helping to build models and sets which are then photographed and made into glossy ads. Four years of art school and this is what he does. Today he is distracted by other things, big, big things. Someone across the table asks what kind of production budget they will need to build the set for the new aortic valve shoot and he is staring out the window at the snow and Mr. Munday calls his name and he nods and pushes his black glasses up the bridge of his nose and looks down at his notes and he murmurs the first number he sees and everyone is looking at him and Mr. Munday asks, "Jack, are you okay?" and Jack shakes his head and says, "No. Excuse me," and then he stands, walking out of the conference room, and heads over to his desk. He opens his briefcase and finds the silver tape recorder inside. He hits rewind and then play and listens to the pink balloon hovering in the air. He hits rewind again and listens to it once more and it is like he is not there, at his desk, in the office, falling into his seat. And then the black telephone begins to ring. And he places it against his ear and is surprised at how cold it feels.

"Hello," he says. "Production department."

"Hi," she says. "It's me."

"Oh, hi," startled all of a sudden.

"Are you still going to go with me tonight?"

Jack nods, even though she can't see. "Sure."

"You don't have to, you know."

"No, I know. But I want to."

"Jack, I think maybe ..." but she doesn't finish her sentence. There is just the steady electronic pulse of neither one of them speaking, until finally she coughs a little and says, "My flight's at eight."

"I'll be there," he responds, and then hangs up the phone, staring at its black rectangular shape, as if it has just betrayed him. And he holds the tape player up to his ear and listens to the sound of the balloon playing there again. And for some reason it reminds him of her. And so he does no other work for the next hour, only listens to the tape playing, ignoring the noise of the people moving all around him. And then he remembers what he's supposed to do today and so he climbs out of his seat and sneaks across the office.

OFFICE JOB.

A few moments later Jack walks past the girl Jill at the front desk toward the PHOTOCOPY DEPARTMENT and the four machines are already going and the intern Daniel is looking over the copy requests and the sound—the thrum, the mechanical buzz, the paper whooshing into the tray covered in fresh ink, the clatter of the stapler, of the paper as it is automatically collated—it's the sound of these copiers that he loves the most about working in the office. It's like the sound of nothingness. Or airplane engines crashing. Daniel says he's going to go get some coffee and Jack says great and then Daniel leaves and then Jack glances over his shoulder to be sure no one is watching and switches the job on copier one to copier three. And then it's go time.

BECAUSE HE'S A CARTOONIST. AND A MUSICIAN. AND A DABBLER TOO.

Because he works at a faceless corporation, he is often asked by various friends to make fliers for their awful art bands, bands with names like VIDEO GAME FEVER and STANISLAV LEM'S NIGHTMARE. And he sneaks these onto the copy machines whenever he has a chance and sometimes his friend Birdie asks him to make copies of her cut-and-paste zine, which is called *YOU AND YOUR VERY INTERESTING BEARD,* and there are always pencil drawings of many different hairy beards talking to one another, having these very philosophical discussions about art and literature, like Lenin's beard talking to Walt Whitman's beard, but today he is making copies of his own work, which is a comic strip he started back in art school called *LOG,* about a young boy who goes to a museum and sees a petrified log, and how the boy falls in love with the log, and escapes with it, and the comic strip follows their adventures together, which is secretly all about his relationship with Elise, though even to her it's thinly veiled, and almost always upsetting. And in this episode, which is just crudely drawn black-and-white line art depicting the boy holding the petrified wood, the boy is asking the log, *What do you want me to do now?* and the log does not answer and so then he drops it over a bridge into a snowy river, and the log, the petrified wood, floats away, and the boy waves to it and then rests his head on the railing of the bridge and says, *What the fuck do I do now?* and then the docket is cleared on machine one and he slips the comic strip onto the machine, and it is at

that moment when the office manager Charlie comes in, her long earrings dangling, flashing like some kind of alarm.

And at first she just smiles awkwardly, places her copy order sheet on the pile beside the work desk, and does not say anything—and he tries to stand in front of the copier as it shoots out page after page of his comic which ends with the gigantic phrase, *What the fuck do I do now?* and so he asks Charlie, "Did you get that info on the Plaxic shoot? They want us to build another giant stomach?" and she coughs a little and says, "I think so," and he says, "Great," and she says, "Good," and he sees her glance down at the copier behind him on her way out, looking more than a little stiff-necked. But nothing happens right away. No one calls him from the black telephone at the corner of his desk, no one peeks their head inside his cubicle to see what he is up to now, and at noon, when he goes to lunch, no one says anything.

But when he comes back, there is a pink message that says, *See Charlie,* and when he looks up there is the office manager at the end of the aisle, nodding at him. She's motioning to him, entreating him to come talk to her, her drawn-on eyebrows rearing up. And he doesn't go. He doesn't know why he doesn't go. He knows he is not going to be fired but he doesn't want to have to talk to anyone right now. He doesn't want to have to explain everything, why he walked out of the meeting, what the comic means, and his lack of attention these last few weeks, and what's going on in his personal life right now. And so holds up his finger, like he's in the middle of something, and then grabs his coat from the coat rack in the break room and runs out.

TAPE RECORDINGS.

And he does not go home right away. He does not want to see Elise, he does not want to see her pale yellow scarf, he does not want to see her put on her white winter hat with the ball on top and then pick up the matching suitcases, which were actually a gift from his stepfather, and say whatever it is she is going to say. And so he rides around for three more hours, until it's dark, through the ice and wind, recording the lost sounds of the city. As he pedals, he notices that on almost every other corner there is a shabby newspaper stand, and on the covers of all the newspapers and magazines are headlines shouting some remarks about the ongoing impeachment trial. There always seems to be some new and lascivious detail or a photograph of the president looking contrite. Jack has been ignoring all of this, as his own personal life is depressing enough. And so he rides along, trying to distract himself, recording the unending disquiet of the people passing along the crowded streets: A woman coughing at a bus stop. A neon-blue pharmacy sign buzzing. A trumpet player blowing his instrument in the cold. And there, at the corner of Michigan and Oak, he stops and sees a green glove lying in the snow.

It's one of the most interesting gloves he's ever seen, elbow-length with narrow fingers, obviously some girl's.

And so he reaches into his gray coat pocket, finds the silver tape recorder, and then leans over, recording ten seconds of the glove lying there. "A green glove in the snow," he says. "Do they have green gloves in Germany, Elise? Probably. Probably. They're probably better than the ones we got here.

They're probably way more functional. They're probably all going to grad school and studying economics. And they're all going to be way happier. Happier than they ever thought," and he says all of this directly into the small microphone. And then he slips the tape recorder back into his pocket, pulls up his hood, gets on his bicycle, and begins to pedal toward home.

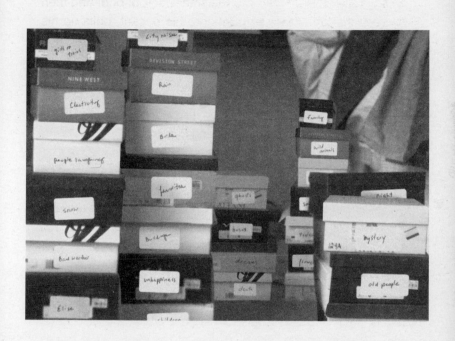

IT'S ALL BEING ERASED.

And the front door is unlocked and there are the two suitcases, placed side by side, to the left of the sofa. And she is pacing around, asking, "What did I forget?" and he wants to say, *Everything?* and he takes a seat on the couch, which no longer feels like his couch, their couch, and the gray cat comes over, and it acts like it doesn't recognize him, because it's her cat, really, even though It's staying with him, and the cat has an air about it now, it arches its neck against his hand and he gives it a pet but it does not seem interested, and everywhere there are his stupid shoe boxes, stacked eight or nine or ten high, in awkward-looking towers, dozens and dozens and dozens of these boxes, and each of these boxes are labeled by theme, like *CRYING* or *CRIME* or *EPIPHANIES*, and in each of these boxes there are four or five or even ten minicassette tapes, each of these labeled by theme again and also date, and Jack sits on the couch, staring at the idiotic shoe boxes sprawled around, knowing this is one of the reasons why; all this childish nonsense, all these unfinished projects have to be what's ended this, their relationship, and there in the corner is his desk, which is piled high with manuscript pages for a screenplay he will never get done, and there beside the reclining chair is his oboe, which he hasn't played in months, and Elise has curled her hair for some reason, and it looks elegant, and he can see her clear braces which make her teeth sit funny, and she's doing that thing, tilting her head to put on her earrings, and Jack stands and says, "I recorded the sound of a balloon today. It made me think of you."

And she looks at him and smiles a sad little smile, the smile of a kindergarten teacher looking at the drawing of a rather dull student, and she tilts her head to the other side now and affixes the left earring, and he says, "I recorded some snow too. In case you wanted to take it with you. The snow in Germany might sound totally different," and here she pats him on the shoulder, and the pat just about breaks his heart, because it is the pat of someone who is about to leave, someone who is done, someone who is going away and never coming back, and she says, "You keep it," and she turns to pick up her purse and it's then that Jack kicks the cat.

"Why did you just do that?" Elise asks, eyes filling up with tears. She leans over and holds the cat to her chest and it leaps from her arms to go hide behind the radiator. And Jack does not know what to say.

"I really don't know," he says, and they both stand there, staring at the spot where the cat had just been kicked. "Shit. This is what you're doing to me. This is the kind of person you're making me."

"What?"

"I got you some Christmas presents. A few months ago. I didn't give them to you because ... But I want you to have them now."

"No," she says. "I don't want them ... Besides, I don't have any more room."

"They're Christmas presents. There's nothing wrong with them."

"Thanks. But I can't." And she nods, tears still coming on in full.

"I'm really going to miss your braces," he says, and then she is smiling and crying at exactly the same time. "They're kind of my favorite part about you."

"What?"

"I don't know too many other people who are in their twenties and who decide to get braces. I think it's pretty great that you did."

"Thanks."

"Do they have good orthodontists in Germany?"

"It's not like I'm not going to be back here at some point. My parents still live here and everything."

"Okay," he says, and then looks around the apartment once more. "You know, we were married for less than a year. Your mom was right: we were way too young."

"Yeah. Somehow it seems a lot longer than a year."

"It does. So do you still have your keys?"

And she nods to the small card table where she has left them.

"Okay. Then here we go," he says, and switches off the lamp. And then, in the near dark, it's like neither of them exists.

IN THE SNOW-COVERED CAR WHICH IS A HATCHBACK.

And the same car he had back in art school. The tape player spits out a song by Guided by Voices and as soon as it comes on, she switches it off. It's from a tape she made him and they both know it. So they watch the snow come down in silence and let the beat of the loosened heater belt be their parting song.

OVER THE NEPTUNE.

The snow piles neatly along the airport's windows though her flight has not been canceled. Below their waists are two pairs of nervous knees and two pairs of uncertain shoes: there are her silver and white heels, and his gray-looking loafers. Neither of the shoes' owners will look the other in the eye and so this is all they see.

"You don't have to do this."

"Yes, I do."

"We could maybe try ..."

"No. Not anymore," and here she points the toe of her shoes away from him.

"But why don't we—"

"Blah, blah, blah, blah, blah," she says.

And then they both laugh nervously.

"But why? Why Germany?"

"It's the only place I can do this. You know that. Okay. I'll call you when I land."

The boarding call warbles its garbled message over the intercom.

"It could be different," he says. "You don't have to leave."

"No, it can't. And yes, I do."

"Please," he says, looking around. "Don't go. Please. Let's not do this. Let's stay married."

And she begins laughing and he isn't and then she sees he isn't and then she feels embarrassed for the both of them.

"This sucks. This is bullshit," he says.

"Auf Wiedersehen," she says, and he can see her feet

disappearing into an aimless-looking line of sneakers and dress shoes and comfortable slippers.

(THEN THERE IS THE SOUND OF
AN AIRPLANE TAKING OFF.)
And he records it with the small silver tape recorder, hoping it
is hers, knowing it isn't.

THEN THERE ARE OTHER SOUNDS
AND OTHER TAPES.
And he tries to record them all.

(There is the sound of an alarm clock. It's ringing somewhere. Somewhere. There it is. Ten seconds of that.)

(It isn't even his alarm, he realizes, hearing it. It's hers, which she forgot to pack.)

(There is the sound of her empty gray pillow, of the empty side of the bed, which is like the sound of a gallows. Twenty seconds of that.)

(And a sigh he makes that is like nothing he has ever heard come out of a human being's body. Which he does not bother to get on tape.)

(And there are his bottles of Lexapro and Wellbutrin, which he has not taken in days now. Four seconds of each of these pill bottles sitting beside the sink, unused.)

(And the song that's playing on the alarm clock right now is Hall & Oates. And he records some of that. Why? Why not? And then he holds the tape recorder up to his mouth and says, "This is the sound of Monday, February 2. You've been gone twelve days." And then he says, "I'm better off on my own. Really. Seriously." And then he sets the tape recorder back

in his lap. And then it's time to get ready for work. But two weeks have gone by and he hasn't been to work and now he probably doesn't have a job anymore. And this is when he stops sleeping normal hours. And he doesn't return anyone's phone calls, not his friend Birdie's or his other friend Eric's. And so he begins riding around the city all night long, looking for interesting sounds to record.)

TAPES.

But it's getting late and he's been riding his bicycle around for a while now: it's kind of awkward to watch but that's okay. In the unplowed street, he almost falls off the bicycle twice. This city, it's a random clash of single noises, and he tries to record them all, steering the ten-speed with his right hand, holding the tape recorder out with his left.

A couple holding hands, splashing in a puddle together. Five seconds of that.

The elevated train roarlng by sounds like a kid whose teeth are all being pulled out at the same time. Ten seconds of that.

Someone sneezing into a pink handkerchief.

A car skidding in the snow.

There's a poodle barking at its own reflection in an icy window. Five seconds of that. And he looks down at his calculator watch and sees it's five to ten and he decides he will ride around until the sun comes up so he doesn't have to try to sleep by himself again.

BECAUSE THIS IS WHAT HE'S BEEN DOING.

Ever since he graduated art school four years ago: recording sounds, almost any kind, the noises, the exclamations, the abstract music of the nervous city. There are minicassettes, more than four hundred of them, in shoe boxes rising like modern buildings all around the apartment, from the front door to the bedroom closet to the bathroom. All these tapes, all these shoe boxes, are probably part of the reason why Elise decided to leave. He knows this now and does not blame her in the slightest. Because it's just one other unending project that keeps getting bigger and bigger. And he doesn't know why he can't just get rid of them all. Because there's just something about the tapes that he loves, something he can't explain. For example, in the shoe box marked *CRYING*, there are five or six tapes of nothing but the noise of people sobbing in public. And each of them are incredibly lovely in their own way. Another box is *GIRLS ON SUBWAY*, and mostly these are just tapes of girls, pretty ones, reading books or folding their legs, or dreamily staring out the windows of the train, or even snoring. And there are other boxes: *BAD WEATHER, CRIME, HAPPINESS, FAMILY, NEWS, DEATH, MYSTERY,* and *BIRDS,* each of them filled with tapes that are stark or strange or sublime. And it's a whole world, a self-portrait of his life built through single moments of sound.

And there is a box, somewhere in one of those piles, which is marked *FAVORITES*, and there are exactly five tapes inside. One is from the intersection near Division Street and Ashland—an old woman singing "Look for the Silver Lining"

to a fountain of warbling pigeons, their coos being what he assumes is the birds' way of showing their appreciation.

Another tape is full of nothing but weather reports from the local radio station—the wordy weatherman describing a cloudy day as *"gray cumulus, just like ponies jumping over a fence."*

One sound, which he has titled Mystery Sound #20, is a strange ghostly whistle, which used to come from the bedroom closet every night. And together he and Elise would listen in wonder and laugh.

Another tape is a series of long knock-knock jokes between two young black girls which Jack recorded on the westbound Chicago Avenue bus.

"Knock-knock."

"Who's there?"

"Banana."

"Banana who?"

And then there's Jack's favorite tape ever, of all time, which he recorded at the Milwaukee Avenue bus stop, the sound of a young woman in a purple coat talking softly to the young man beside her, and which goes exactly like this: *"I ate a plum today and thought of you."*

And he does not know why this is his favorite sound of all time, only that there is something so perfect in its briefness, in its sense of longing. It's the way he has been feeling for some time, and in the sound of this other person's words, the plastic cassette tape itself is maybe the most beautiful thing he has left in his life.

And so he will sit on the floor with all these tapes, ignoring the phone, ignoring the gray cat, and play cassette after cassette, searching through the stacks of shoe boxes for the perfect combination of sounds. And he will hold the silver tape player in his hand and hit rewind and then press play

and there will be the sound of the pink balloon drifting through the air, the alluring distance of its soft flight, resounding from the single silver speaker. And he will smile and rewind the tape again and then turn, seeking out a white shoe box which once held a pair of beige loafers, and find it shoved in the corner, sixth from the bottom of the stack. Along its lid, the box says *SNOW*. He will lift off the white lid, remove a cassette labeled *Snowstorm 12.29.1998*, and place this new tape inside a second tape player, a rectangular black one, from the 1970s. And he will adjust the volume and then press play on this second recorder. And the sound of the snow—like a pause, like a musical caesura, almost silent—will echo from its small black speakers. And he will play the two tapes together—the sound of the balloon and the noise of the drifting snow—and then decide something is still missing. And he will search among the towers of tapes for one more box—*ELECTRICITY*—and finding it, he will select a third cassette. And this third tape will be placed inside an old answering machine. And then he'll hit play again. And the third tape will fill the air with a hollow buzz, the sound of streetlights vibrating in the morning, and for a moment it will be perfect, the sound of all three tapes playing at the same time, and a city—a city of sound will surround him—and he will be among its quiet avenues and soft-lit boulevards. And the idea is that all these tapes, all these separate noises, are actually a city, a single town he has invented made of nothing but sound.

And it's what he's been working on for almost four years now, this invisible city, built one sound at a time, each noise a different place on an imaginary map, a different spot or intersection or park or corner or window in an imaginary town, where language is unnecessary, where nothing bad ever happens. It is the only part of his life that seems the least bit remarkable, this imaginary city, and nobody knows about it

except Elise. And now she's gone. And he doesn't know when it will be done, if ever. And tonight as he's pedaling around, tape recorder in hand, it begins to get cold and so he decides to call his friend Birdie because he's always had a friendly crush on her, and she says hi and asks if he wants to come over and listen to some records and so he momentarily forgets about the imaginary city and says he can be at her apartment in ten minutes. How does that sound? Okay, she says, and off he pedals again.

LISTENING TO RECORDS.

And so he sits on the floor of Birdie's apartment and she is listening to the Talking Heads and she asks how he is doing and her voice sounds concerned and he says okay and he says he doesn't want to talk about Elise or anything and so he takes out his tape recorder and hits record and then asks her: "Have you ever done anything remarkable?"

And she looks at him and then at the tape recorder and says, "What? No. Once, in high school. On the swim team. I won this meet. I was the last—you know—on the relay team, and I usually was the weakest, but this one time, I don't know. It all came together. I never swam that hard in my life. I think I actually pooped a little in my swimsuit if you can believe it. And that was the only time I did anything the least bit exciting."

And he says, "I'm trying to figure out what's wrong with me. And I think I realized that I'm average, that there's nothing remarkable about me. And I wanted to know if this is something other people think about."

"Not really. You can ask me another question if you like."

"Okay. Do you think I'll ever do anything remarkable?"

"I don't know. All signs point toward no right now."

And then they both laugh sadly.

"Okay," he says, thinking. "I have all these Christmas presents I bought for Elise. Like three of them. Do you think I should just throw them out?"

"Yes, I really do."

"You don't want a new hair dryer, do you?"

And here Birdie laughs again and says no thanks. She is

cute—with her black hair cut in a kind of bob and cat's-eye glasses and the small buttons she makes for local bands in her spare time, which dot the collar of her various cardigan sweaters—but she has a boyfriend, Gus, who lives in New York, who might be a nimrod, because Jack only met him once and did not think much of him.

"What other questions do you have about life?" she asks.

And he asks, "Do you think I have a big nose?" holding out the tape recorder again.

"What?"

"Do you think my nose is funny-looking?"

"What? No. It's totally normal."

"I think it's a little too triangular."

"You're crazy." And then she asks, "What about me? Do you think my head is too small for my body?"

"No. It's totally proportionate. I always said that about you. She's very proportionate."

And Birdie laughs again. "What about my glasses? Do you think they're dorky?"

"No. What about mine?"

"No. What about my hams?" she asks.

"Your what?"

"My hams." And here she stands and points to her backside. "My hams."

"No. I think your hams are pretty okay." And then he knows it is his turn and says, "What about my forehead?"

But she doesn't answer because someone begins kissing someone else. And then Jack switches off the tape recorder and sets it down and goes on kissing. And he lifts her shirt and gets his hand down her pants and looks and sees she has written, in black magic marker, the word GUS'S with an arrow that points down to her lap, disappearing beneath the top hem of her pink underwear.

"I thought this was going to happen," she explains.

"Nice," Jack says, and Birdie laughs but they continue kissing. And Birdie is slipping off Jack's belt and has her small hand down the front of his pants and so he decides to try and reciprocate, and puts his fingers down the front of her underwear, and she shifts her weight so he can get his hand underneath, and the Talking Heads are still playing and Birdie says, "Gus doesn't care as long as I don't fall in love," but who's to say how a thing like that happens?

APPROXIMATELY EIGHT MINUTES LATER.

Both of their heads appear above a white sheet. That's all. It's as if their bodies have disappeared. A pile of their clothes has been assembled at the foot of the bed. And Jack's mouth tastes furry. And the girl, Birdie, turns her face, with its frame of dark hair, to stare at him.

"Was that a little weird?" Birdie asks.

"What? No way. It was nice. I mean, you ... you're great."

"No. It was weird. It was bad."

"It was nice," he says.

"No, it was like ..."

"Doing math," he says.

"Like going to the dentist."

"It wasn't that bad."

"No. It was. It was," she says. "I think I stopped paying attention at some point."

"Maybe it's because we're too good of friends," he says.

"Maybe."

And Birdie is sitting up, pulling on her pink see-through underwear, and then her jeans, and then she is finishing clasping her bra. And he starts getting dressed too, and she looks over at him and says, "I knew it was probably going to be bad but I didn't stop you. It's a problem I have. I'm only good in bed with Gus."

"It's okay. It's no big deal."

"Do you want to watch a movie or something? Have you ever seen *Freaks*? It's by the guy who did *Dracula*."

"No, I haven't seen it. But I should probably get home.

I've got this thing I'm working on," he lies. "I think I need to finish it."

"What is it?"

"Nothing. Just ... this project. It's nothing, but I just want to get it done."

"Okay. Sure. Well," and she doesn't say anything else.

And then he pulls his winter coat on, even though his pants aren't buttoned. And he thinks of how he will probably never be back in this apartment again, and how weird things will be with Birdie from now on, and he doesn't know why but he decides to shake her hand very formally.

"Okay. We should never do this again," he says.

"Agreed," she answers, and then they do not look at each other, both of their faces going red.

AND AFTERWARD.

He grabs his blue ten-speed from beside the front door of Birdie's apartment and walks out into the cold before he even has his pants properly buttoned. So what? His shoes are unlaced and he almost kills himself trying to get down the stairs, but at least he's not feeling as embarrassed as he was. And he decides he's going to go home. He's going to go home and really try to finish something.

BECAUSE THERE IS HIS SCREENPLAY
AND ALSO HIS BAND.

His band is called The Royal We and it is an avant-garde instrumental group, which plays covers of television theme songs, music from advertisements, and melodies from black-and-white-era cartoons. He plays oboe in the band, and Kate plays keyboard, and his only other friend Eric plays trombone, although they have not practiced in more than four months. Their last show was a tremendous failure with only twelve people attending. But he could always try to come up with some new ideas for the band. And then there is also the screenplay he has been working on for a few years now, tentatively titled *The Crystals,* which deals with a city where the people and buildings are all turning into crystals, which is sort of an abstract horror movie, or at least this is what he's recently decided, but maybe it's really about love, because whenever someone who is a crystal touches someone who isn't, they automatically become a crystal too, and sometimes these crystal people—as they're walking around, trying to go about their lives—sometimes they end up breaking apart. And so there are parts of crystal people lying all around. And as he's riding on his bicycle that night, he gets a new idea for the screenplay: What if the crystals made weird sounds when they broke apart? What if they flashed and made weird sounds, and the city became louder and louder the more broken crystals there were? And what if the hero, Robert, what if he was trying to find his girlfriend Veronica and he kept getting lost in the city because buildings he recognized kept

turning into crystals and people were trying to turn him into a crystal too, and the sound of everything just kept getting louder and louder? And why is this city so loud? Is Berlin as loud as this? And hell, what does Berlin look like at night? What is Elise doing right now? What time is it in Germany? All these questions but the city doesn't seem to answer. And when he gets back to the apartment, he doesn't do shit but stare at the telephone, trying to will a call from Elise that he knows isn't coming.

US AND ALL OUR FRIENDS ARE SO MESSED UP.

And the following day Jack is asked by his friend Eric to help him move, even though it's snowing like crazy. Eric has a large black beard he's a little too proud of. He and Kate, his long-time girlfriend, play music with Jack in their amateurish band, although Eric's day job is as an English teacher at a small high school. A few years ago he used to wear a pair of black leather pants around. And now. Now he teaches Shakespeare. All these changes, all these people changing. Recently, Eric got in trouble at school for standing on the desk, trying to reenact the scene from *Dead Poets Society.* Dumb. He was trying to inspire these kids, but it was still a pretty stupid thing to do. And now he and Kate are moving. Jack doesn't even know where to. And Jack shows up at their apartment and sees Eric's old-model Volvo parked out front, already loaded up. And there are boxes in the hallway on the second floor, and Jack knocks on the open door, and Kate is sitting on the couch, sobbing. And Jack asks, "What's wrong? Aren't you guys ready?" and Eric is standing there, folding his hand into his beard. And he's shaking his head. And he says, "She didn't know."

"She didn't know what?"

"That I was moving out."

"You're moving out?"

"Yeah."

"I thought you were both moving."

"No."

"Wait a minute. You just told her?"

And Eric nods, still with his hand in his beard. And Kate is still crying and then she stands and says, "Get out of here, you stupid assholes," and then they do.

"This is what happens when love goes wrong," Eric says, carrying out a cardboard box of pornographic magazines into the hallway.

And that's all he says about that.

AND A WEEK LATER.

And then it's Saturday night and Birdie calls and asks him if he wants to go to a party with her and he says okay, and she says it's an Imaginary Building party, but he does not have a costume, but that's okay too. Everyone is supposed to take a cardboard box and make a building out of it to wear but he can't find any cardboard boxes except for the ones in the alley behind his apartment and they are all covered in snow, and so he has his gray winter coat on and he has decided to wear his banana shirt, and the banana is chasing a donut, and it's a shirt he made four years ago in a silk screening class in art school and isn't all that funny anymore. And Birdie is dressed as the Eiffel Tower and she looks pretty great and both of them are riding their bikes to the party. And at a stoplight, she turns to him and says, "I don't know if we can be friends anymore."

"What?"

"I told Gus what happened. He's pretty pissed. He doesn't want us hanging out anymore, alone, together, whatever."

"But why did you invite me to go to this party with you?" he asks.

"I don't know. Because. Because I like hanging out with you. And Gus isn't here. It's too hard going everywhere alone."

"So do you want to stop hanging out?"

"No. But I probably should. I mean, maybe if you got a girlfriend. If you were dating someone, then all of us could hang out. It's just weird right now because you're not dating anyone."

"Right."

"You can still come to this party with me tonight. Parties are okay. I mean, anything with a lot of people."

"Like a parade."

"Exactly."

"Or a funeral."

"A funeral would be great."

"Great," Jack says, wishing he had stayed home. But it's Saturday night and he wants to be out, he wants to be out among the people.

And then he is at the party and Birdie walks away to say hi to someone, and someone else he doesn't know is standing on the sofa, dancing, dressed as an imaginary building, and other people are talking to each other in pairs and groups of three and four and someone has spilled their drink on the façade of their friend and everyone asks where Jack's costume is, and someone is dressed as the Chrysler Building and someone else is dressed as the Eiffel Tower and from across the small apartment Birdie rolls her eyes and the music is loud and it's a band Jack has never heard before and he has to hold one finger in his left ear to talk to anybody and he finds a guy he knows named Pat who's dressed as the Brooklyn Bridge and who points in the direction of the tiny, white-tiled kitchen, and Jack makes his way through the improvised city and opens the refrigerator door and takes a beer and there beside the refrigerator he sees a girl he has met once or twice, named Leigh G, not Leigh M, and she is dressed as a beautiful silver castle and has sparkly makeup on her cheeks and false eyelashes and a tiara on top of her dark hair. And she smiles and seems to recognize him. And then she is whispering in his ear.

"Could these people be trying any harder?" she asks.

"At what?"

"At everything."

"You're the one dressed up as a castle," Jack says, smiling widely.

"I know, but it was just supposed to be a joke. I was trying to be ironic."

"Oh." Jack nods and looks down at the girl's silver shoes. She's petite and her feet are very small.

Someone dressed as Big Ben and someone dressed as a chapel, complete with steeple, are now making out right beside the refrigerator. The girl Leigh seems bothered by this.

"Are you still in that band?" she asks. "I think I saw you play one time."

"No, not really. I mean, I was. I still play the oboe, on my own."

"Oh. I thought it was pretty bad. But at least it was interesting."

"Thanks. I'm kinda ... I'm kinda focusing on other things now. I'm doing some abstract art. And a couple sound installations. And I'm working on a screenplay. And a couple other things too."

"Are you still in school?"

"No. Not anymore," he says. "I mean, I graduated like four years ago. It's taken me some time to figure out what I want to do."

"I have no idea what I'm doing either," the girl says. "Everything seems so ... obvious."

And Jack nods.

"Are you working?" she asks. "Do you have a job?"

"Not right now. I had a job. I'm basically trying to work as little as I can so I can do other things."

"That's what I want to do," the girl says.

"What about you? Are you ..."

"I work at an insurance company."

"Okay," Jack says. "What's that like?"

The girl looks at him, studying his face. She seems to be calculating something, adding something up. And then she says: "Do you want to get out of here?"

And here Jack smiles and then, instinctively, pats down the back of his hair.

"Really?" he asks.

"I don't know," the girl says, unconvinced. "Why not?"

And on their bicycles together, they ride through the snow, Jack laughing at the sight of the girl in her outfit, her white legs covered in sheer tights, rising up and down. Someone honks at them, and then a bus swerves past, and Jack asks, "Why don't you take your costume off?" but Leigh says no. They pause at a red light a few blocks later and he looks over and sees the shape of the castle she is wearing and how red her cheeks are from the cold, and then he says: "You look really pretty."

"What?"

"You look pretty."

The girl rolls her eyes and smiles and says, "Thanks," and then the light changes green.

"Do you want to go to my place?" the girl asks, and Jack nods, surprised.

"Really?"

"I live off of Wood. Plus my roommate's not home. I could show you my little brother's notebooks."

"Your what?"

"His notebooks. From high school. He used to write his speeches in them. He was on the debate team. My parents made him join. They're hilarious. His speeches. There's this one about *Star Trek* that's just ridiculous. I make everybody I know look at them."

"Okay. If you want to."

Then, as if she's still deciding, she finally blinks and says, "Okay."

And they pedal off in the direction of the girl's apartment, only five or six blocks away.

And as they go, Jack stops at a light at Division and Ashland and the girl pauses beside him, both of them atop their bicycles. And the snow is still coming down and Jack reaches into his gray winter coat and takes out the silver tape recorder, and the girl asks, "What's that?" but Jack doesn't answer; he just holds the tape recorder up and hits play and record and the sound of the snow drifting down and floating through the air somehow seems to grow louder, and after ten seconds Jack holds the tape under his chin and says, "Snow, at the corner of Division," and then he switches the tape player off.

The girl looks at him and smiles and Jack shoves the recorder back into his coat.

"What was that for?"

And Jack doesn't bother to try to explain.

A few moments after that, they are quietly climbing her rickety stairs, carrying their bicycles beside them. And then her key is in the door.

And then they are sitting on the girl's couch and she is showing him her brother's high school composition notebooks, and there is a blue one, and another one that is orange, with a rounded wire edge, and she flips to a specific entry and says, "Here, read this out loud," and Jack asks, "Really?" and she says, "Yeah. I make everybody do it," and he nods and sees the girl is probably a lot younger than he thought she was and he starts to read, "*The technology in the TV show* Star Trek *is not real; it's fake. But many scientists argue that what we see in the movies and on TV could one day be real. Why not? It happened with rockets. And also escalators ...*" and here Jack

stops reading and looks at the girl and she is laughing and saying, "Isn't that the funniest thing you ever heard?" and he is nodding but he doesn't think it's actually all that funny. It seems like something he might have written in high school or maybe even yesterday; but he doesn't say anything because they are kissing now and after a minute or two, he asks if he can use the bathroom, and it's then he decides he has to come up with a reason to leave. Because this girl is too young and dismissive. And all he can come up with is to fake a stomachache, and when he comes back out, he says, "I'm not feeling so hot," and the girl asks, "What's wrong?" and he says, "I think I'm gonna take off. I don't want to get you sick," and she says, "What is? What's the matter?" and he says he has a bad pancreas and holds his left side, even though he has no idea where his pancreas is, and the girl nods, and it's nice to see her look concerned, and then he lifts his blue ten-speed from beside the front door and hurries off.

AND THEN.

Only a few moments later, Jack is pausing at a stoplight, recording the sound of the traffic light making its alterations overhead—the noise of the different colors switching from one to the next, a specific, mechanical sound—and when the light turns green, he rides off again. Before he can stop himself, he sees a small-model foreign car turning in front of him, and although he knows what's going to happen, this realization is about one second too late. The red foreign car hits the rear tire of Jack's bicycle wlth the corner of its front bumper and Jack flies over his handlebars and lands on his back, and there he lies, groaning, watching his blue ten-speed ride off without him. And then his left eyetooth begins to throb. And he looks up and sees a girl, somewhere in her twenties, her eyes brown, her hair blond, wearing a green coat and red sweater, mouth agape, standing above him asking, "Oh, my, God, Are you okay? Are you okay?" and he sits up, his back and elbow sore, his eyetooth throbbing, and tries to straighten his glasses. He gets himself to his feet and stumbles around a little, the girl reaching out to catch him, but Jack backs away, murmuring, "Don't. I'm okay. I'm okay." And on wobbly legs, Jack finds his tape recorder, still clutched in his hand, and it's okay, it's not broken, and he holds it up to his mouth and says, "This is the sound of me getting hit by a car," and records a few seconds of that before limping off, saying "Ouch" each time his left foot comes down.

AND THAT NIGHT THERE IS AN ANGRY MESSAGE FROM HIS LANDLORD.

Taped to his door. *Where is The Rent? Is It missing? Is it in The Mail? Did you Forget to Pay? Do Not screw Me,* it says. *I have BAD Friends.* And this is exactly the kind of thing Elise used to take care of and so he finds out how much money he has in his checking account and sees, apparently, he's going to need a job again.

And so he looks in the want-ads the next day and finds a job listing that says: *Night-owl? Having trouble sleeping? Make big cash working at Muzak Situations, Madison Ave. Great Temporary Work.* And he faxes them a resume from the local copy shop but doesn't hear anything back that day. And still he can't sleep. And the screenplay is not going well and so he realizes he has to do something. And so he calls his stepdad, David, who is a highly regarded psychiatrist. And his stepfather calls him back and asks him what's been going on.

"Nothing. I'm just. I've been having a hard time sleeping. I haven't slept in a couple of weeks."

"Are you taking the same dose of Lexapro?"

"I am."

"Hmmm. Do you want me to prescribe you some Ambien or something?"

"No. I think I'll try and rough it out."

"How are other things?"

"Pretty good. Except I hurt my tooth last night. I mean, I really hurt it."

"What happened?"

"I fell off my bike."

"You fell off?"

"Someone hit me."

"You should get someone to look at it. You shouldn't mess around with your teeth, Jack. When's the last time you went to the dentist?"

"I don't know. Maybe a couple years. Four or five."

"Why don't you go see Ray?" Ray being Jack's second stepfather.

"I don't know. I haven't talked to him in a long time."

"He's very good. And you wouldn't have to pay him anything."

"I really don't talk to him anymore. I mean, my mom ... They're divorced now."

"I'm sure he'd take a look at it."

"Really?"

"Sure."

"Okay."

"How's your mother doing? I heard she got remarried again."

"She did."

"Yikes. Fourth time's a charm?"

"Yeah. Maybe."

"Well, call my receptionist and let's schedule lunch together sometime. I haven't seen you in a while. We need to catch up."

"Sounds good," and Jack hangs up the phone and wonders what he is so afraid of. Why doesn't he want to talk with his stepfather about what's going on? And then he holds his hand to the side of his mouth just above his sore tooth and groans out loud.

A DENTAL APPOINTMENT.

Off he goes to his second stepfather's dental office on Monday and looks at the lobby directory which lists Ray's practice on the third floor. Jack takes the stairs because the elevator is out of order and he carefully opens the glass door and enters the office. The waiting room is beige. The magazines on the dark wood table all have to do with golf. Jack takes off his gloves and hat and signs his name at the front desk. The receptionist, a radically beautiful young woman with long white-blond hair, holds a black phone to her ear and smiles.

"I'm here to see Dr. Ray," Jack says. "My last name is Blevins."

"I'll see if he's available. Please have a seat."

Jack takes a seat, directly across from a good-looking girl in a dark turtleneck, who is flipping through a glossy magazine. The girl is maybe twenty-five, twenty-six years old. Jack watches her for a moment. She nods at him and smiles a curt little smile, which is just enough as she has the most darling dimples he has ever seen.

"Hi," he says.

"Hello," she says.

"I really hate going to the dentist," he announces as much to himself as to anyone else.

But the girl nods.

"I really do. I don't know why. Are you nervous at all?" he asks.

The girl looks up and smiles, surprised. "I'm okay." She directs her attention back down to the magazine.

"I used to be nervous whenever I had to go to the doctor when I was a kid," he says. "My parents are doctors, though. Which is weird when you think about it. But they're shrinks. So that doesn't really count. Actually, my father and mother, and also my stepfather, are all psychiatrists. Or psychologists. I forget which."

The girl nods.

Jack retrieves the silver tape recorder from his pocket, pointing it directly at her. "Do you mind if I ask you a couple questions? It's for this project I'm working on. I try to interview different people when I meet them. It's just this thing I do. Is that cool?"

" — "

"Or do you mind?" he asks again. But the girl does not respond, only turns her attention back toward the magazine.

"Okay. How about this. Here's an easy one to start off. Do you think my forehead is too wide? Be honest."

The girl breathes a little hassled breath through her nose.

"No. Okay, what famous person would you be and why?"

The girl looks at him and frowns and then says, "I'm just here to get my teeth cleaned."

Jack nods and smiles. His eyebrows are raised as he points timidly. "It's just ... you have really great dimples."

"Thanks," she says, but does not look up.

"I usually don't notice people's faces, but you ..."

The girl nods, afraid to look him in the eyes.

"They're just nice-looking. Your dimples. That's weird-sounding. Talking about someone else's dimples," he says.

The girl stands, sets down the magazine, and then crosses the small waiting room to the receptionist's desk. She whispers something to the receptionist, who peeks over the edge of her modernist furniture to stare derisively at Jack.

Jack then finds himself standing, forcing the tape recorder

back into his pocket, feeling incredibly embarrassed. His face is now bright red. He gathers up his things, pulling his hat and gloves back on, and leaves in a hurry.

AND TO HIS MOTHER'S APARTMENT.

Before the elevator doors close in front of him, he has already decided that he is done, done with human relations of any kind—that all these feelings are hardly worth it. He is going to talk to his mom, who is a psychiatrist and probably the most reasonable person he knows. He's going to tell her everything. The elevator doors begin to close before him as Mrs. Canarski from the fourth floor approaches with her famous toy poodle. But Jack does not try and stop the doors from closing. The elderly lady looks at him as if she has just been slapped. The poodle barks a sharp note in protest. The old woman, struggling to hold the animal, spills a bag of groceries, and a single orange rolls inside the elevator. The doors close. It is quiet. It's the first time there's no noise and Jack looks down and sees the single orange lying at his feet and then it is like a moment from a dream; it is happening but not yet happening. And he feels like something in him is giving up. Something's changing.

The apartment is quiet when he enters; he mumbles an awkward hello but hears no answer. What now? He is feeling worse than he has in months and so there is only one thing to do. He locks the top and bottom locks of the front door, and then tiptoes into his mother's bedroom, the bedroom she shares with her fourth husband, a man named Reg, and he opens the medicine cabinet and begins sorting through his mother's prescriptions. He takes a Valium and then a Xanax and then another Valium, swallowing them with a glass of cold water, and then he takes a handful of each and puts

these in his pocket. And then he walks around the empty apartment, his footsteps filling the air as he makes his way to the corner of the den where the ancient hi-fi stands. The stereo, with its cassette player and turntable, once belonged to his grandfather, his mother's father: it is brown and beige, the knobs enormous and etched silver. He can still see his grandfather's fingerprints along the dials if he squints. He flips through several vinyl records—also pieces of his grandfather's collection—and finds the one he has in mind, Debussy's *Children's Corner* suite. He slips the record from its cardboard envelope and places it on the turntable, leaning in close to hear the tiny zip as the needle meets the plastic surface. He turns the volume up as far as it will go, hearing the piano begin to twinkle its upper ascent. There along the antique table are several magazines strewn about, magazines that his mother's patients often page through while they are waiting for their appointments; he reaches for the bottom of the stack and finds an out-of-date *Cosmopolitan.* Carefully, listening to the precarious music build, he turns the pages of the magazine, opening it to a swimsuit pictorial, which features a gorgeous green-eyed model, her décolletage nearly spilling out of her flimsy top. He leaves the open magazine on the coffee table and then begins to pull down his pants.

Moments later he is in his white briefs, thinking of the girl from the dentist's office, of her dimples, and then of Birdie, in her bed, of how serious and soft her body seemed to be, and then how sad everything is, how wrong it all goes, in the end. And then he's not aroused anymore. Even masturbating seems to have become a serious problem. And so, in his underwear, he walks out into the hallway to the closet, takes out the vacuum cleaner—its pink body a horizontal cylinder with wheels, its apparatus a single, lengthy hose with nozzle attached—and plugs it in. It is the sound he likes, the whir of

the machine's motor blades, and also the sensation upon his skin, which is both touchless and clean. In its artificiality, in its machineness, it is unruinable, it is perfect, his relationship with this particular device a remnant of his weird experiments as a teenager when he would masturbate for hours on end, imaginatively using various household items. And so he turns the vacuum cleaner on, pressing the nozzle against his chest. But it is still too personal, the feeling of what he is doing, and so, wanting to feel less like a person, wanting to become totally anonymous, he pulls his white T-shirt over his head and leaves it there as a blindfold.

More than a few moments after that, he is lying on the expensive, multihued Persian rug, his face covered, his underwear around his knees, his right hand groping himself, his left hand holding the attachment of the vacuum cleaner near his groin, when his mother and her new husband come in. His mother immediately begins to scream, her voice ricocheting off the muted walls in small staccato bursts. Because of the blindfold, he does not see the expressions on their faces, and for this he will always be happy.

ODILE
AND
JACK

AND SO.

The girl in the cubicle beside his has the curious habit of peeking at him from beneath the jagged arrangement of her dark brown bangs. Because the phones are quiet now. It is twelve-twenty a.m. on a Monday night in February. Only forty minutes are left in this shift. The rest of the gray office of Muzak Situations has gone still. In addition to the girl in the cubicle beside his, there are two other operators on duty this evening, one of them reading a lurid paperback, the other picking at her equinelike teeth. There is the sense that each of them, all four of these phone operators, are silently occupying the territory of the other operators' dreams. In part, it's due to the subtle sounds of soft keyboards and digital drums playing overhead: it's instrumental music, the kind a person might hear in a dentist's office, which is what they are selling. Beyond the looping keyboards, there's also the air of something temporary about the office, with several cubicles still waiting to be assembled, stacks of merchandise in unpacked brown boxes, the windows blinds themselves not yet hung, as if the office has just been opened or is just about to go out of business. There is the phone and the computer before him, both of which have to be from the year 1988. And then, in the cubicle beside his, the girl keeps staring at him as if he is a bad piece of art not meant to be figured out.

"Have you ever done anything interesting?" she finally asks, blue eyes flashing green.

"Excuse me?"

"Have you ever done anything interesting?"

"Like what?"

"I dunno. Like dropping a water balloon on someone. Or stealing a bus. Or performing an emergency tracheotomy."

"Nope. I can honestly say I've never done any of those things."

"Too bad. Me either," she says, looking away now. She is chewing some sort of pink gum. There is a tattoo on her wrist which kind of looks like a beehive. Is that it? A beehive? Or is it just an oblong scar? She blows a large pink bubble, pops it with her finger, and then disappears behind the turf of the gray cubicle wall. He smiles to himself, adjusting his glasses against his face, and then sees her poke her head back over again.

"Those glasses make you look retarded."

He touches them and smiles sadly. "Oh."

"But they're also kind of awesome. I mean in a fucked-up sort of way. I mean they definitely fit your face."

"Gee, thanks." He touches the black frames again and looks down at his desk.

"I'm Odile by the way," she says, extending a small white hand.

"Jack," he says, and gives it a careful shake.

"Wow. You have really sweaty hands," she says.

"I know. It's why I'm not a big handshaker. I could never be a successful businessman. Or politician. Or surgeon."

"No, probably not." Odile nods a little and then stares at him again. "So I'm starting my own movement and I was wondering if you'd like to join it," she says.

"What's your movement about?"

"It isn't about anything."

"No?"

"Basically, we just sniff liquid paper and try and think of interesting things."

"That sounds okay."

"Do you want to join it?"

"All right."

"The only rule we have is that you have to say yes to everything."

"Really," he says.

"Really."

"Okay. Sounds good to me."

"Okay. Here," she says, handing him the small black-and-white bottle of liquid paper. "Take a whiff. Then you'll be one of us."

He holds the open bottle of liquid paper beneath his nose, its chemical pungency making his nasal passageways itch.

"Who else is in your movement?"

"No one else right now. It's just the two of us," she says.

He nods and takes another sniff and then hands it back to her. It feels like his brain is full of pink and blue circles, each of these circles overlapping. A phone rings and Odile pokes her head back behind the cubicle. As the liquid paper's fumes quell his brain activity, Jack finds himself staring at her again and what he thinks is this: *Wow.*

Question: Where do Jack's eyes go when he looks at Odile?
Answer: The freckles on her nose. Her small breasts. Her long neck.

Question: Where is Odile looking?
Answer: At her own fingernails. She is chewing on them while talking on the telephone.

Question: Does she sit still in her chair or does she swivel?
Answer: She swivels. Back and forth, and the motion of it reminds Jack of a clock ticking off the remaining moments of his life or a heart pumping full of bright red blood.

Question: Are her bangs cut by herself?
Answer: It appears so.

Question: What does he imagine her breasts feel like?
Answer: Small oranges. From Jupiter or Neptune.

Question: Is Jack still in love with his estranged wife?
Answer: Yes, he is. Of course he is. But Berlin is so far. And here. Here is this girl.

BUT IT JUST SO HAPPENS THAT
TEN MINUTES LATER.

Jack goes to get a can of soda from the break room and there is Odile, kneeling on the gray carpet before the snack machine. Her entire arm is stuck up inside the small rectangular opening of the candy machine.

"What are you doing?" he asks.

"I'm trying to break into this machine," she says. "This one always steals your quarters. I'm pretty sure it does it on purpose. Do you mind watching to make sure no one comes in?" and Jack nods, turning to keep lookout over the empty hall. After a moment or two of contorting her face, Odile pulls her hand out, holding several packages of bubblegum. "Here," she says. "For being my accomplice."

"I really don't like gum," he says. "Anyway, I have a bad tooth."

"What's wrong with your tooth?"

"I got in a bike accident. Someone hit me and I ended up hurting my tooth."

"Is it infected?"

"I don't know."

"Can I look at it?"

"What?" Jack asks, more than a little surprised at the question.

"Can I look at it?"

"Really?"

"Sure, why not?"

And Odile nods and Jack shrugs and leans his head back, opening his mouth.

"Wow, you got a lot of silver in there."

"I know. My stepdad is a dentist. One of my stepdads anyway. The second one."

"You have two stepdads?"

"Three, actually. It's a long story."

"Wow. So you don't want any gum?"

"No thanks."

And here she leans against the plastic window of the vending machine and says, "I was pretty serious about what I said. I really am thinking about starting my own art movement. I know it sounds kinda goofy. But I'm really thinking of doing it."

"What are you going to call it?"

"I don't know. The Antiabstractionists. The Anti-Rationalists. The Anti-Intelligents. The Anti-Reasonists. Something like that. Basically, I'm against everything popular. Anything that makes art into a commodity. Or people into commodities. Or anything that's supposed to be a commodity."

"Wow," he says. "That sounds serious."

"Yeah, but it isn't. It's just something to think about when I'm working here."

"It's a pretty boring job."

"It is," she says.

"I've been tracing my hand over and over again."

"I know. I've seen you do it."

"You have?"

She nods. "So are you in or not?" she asks, and then without thinking, he says, "Sure. Why not?"

"Cool."

"So what do we do now?"

And she says, "I don't know. I haven't thought that far yet," and then the night manager, Gomez, appears from his office with his typically sweaty forehead, holding a half-eaten

bologna sandwich in his left hand, and he gives the two of them a dirty look, and so together they hurry back to work.

AND THE NIGHT AFTER THAT.

On Tuesday night, around five p.m., the two of them—Odile and Jack—are in the break room just before their shift starts. And they are staring at each other suspiciously, Odile peering from behind a diet soda pop can, eating a peanut butter sandwich with the crusts cut off. And Jack begins to talk first, asking, "So, are you working tonight?"

"Duh," she says, smiling, with a mouth full of bread.

"I guess so," he says.

"We all know what's going on here. You don't have to be weird about it."

"What's going on here?" he asks, smiling.

"I am not going to even dignify that with a response," she says, smiling again.

"Wait. What do you think's going on here?" he asks again.

But she doesn't say a word, only keeps eating her sandwich, smiling.

He is encouraged by her nonanswer for some reason. *Maybe she's interested in me. Perhaps, well, no, but, maybe.* And so Jack says: "Are you going to order something to eat tonight? On your break?"

"Yes."

"Well, let me know. I'll order something too."

"Fine," she says, still glancing over the top of her soda pop can. "But I'm paying for my own. We're not going steady or anything."

"Okay," he replies, a little disappointed at what she has

said, but not disappointed enough to stop being interested. Because, immediately, he catches himself staring at her again. He catches himself trying to memorize the shape of her eyes and wide face. He watches her get up and leave the break room and then he asks the cloud of air where she has just been sitting why it's so freaking lovely.

And then he punches in on the time-card machine and walks over to his cubicle and Odile is already answering the phone, and he looks downs and sees she's taken her off shoes. Which is sort of weird. And when she finishes her call, she leans back in her chair and looks at him, not saying anything at first. She runs her fingers through her hair, arranging her bangs, and then announces: "We are not going to have sex. I want to tell you that right now. I don't have sex with people I don't know. It makes it too weird too soon."

"I wasn't even thinking that," he says. "Why would you even say that?" he asks, blushing, feeling the heat of his face reaching his neck.

"I know that look you have. I think I know what you are thinking."

"We're adults," he says quickly. "I'm only here to work. I won't bother you or anything."

"Fine," she says. "Great."

"Great," he repeats.

"We're too good of work friends anyways."

"We are?"

"I mean, we're probably too much alike," she says.

"Yeah, it would be too weird. If things didn't work out."

"These things never work out," she says.

"Exactly," he says.

"Exactly."

"Right," he adds. "Exactly."

"And who needs all the weirdness?"

Both of their noses twitch as they peer at each other. She tugs on the corner of her gray cardigan sweater and looks as disappointed as he does and then disappears back behind the gray cubicle wall.

BUT THEN.

But then at one a.m., in the elevator, on the way down to the lobby, Jack zipping up his coat, Odile fitting her white hat over her head and then buttoning up her green parka, she turns to Jack and asks, "Do you want to get some coffee somewhere?" and Jack says yes faster than he ever has said any single word before. And they find their two bicycles parked opposite each other, and both of them unlock their bikes, and they ride side by side through the bleary downtown snow.

AND AT 1:17 A.M. THAT SAME NIGHT.

They get two cups of coffee at a small diner on Chicago Avenue and begin to plan their violent art movement together. It will be called the Art Terrorists. Or the Art Brutes. Or maybe just the Anti-Rationalists. And they discuss these names, straight-faced, as Odile pours two creams and three sugars into her coffee. And then she looks up at Jack pensively and says: "You know, those are some really weird-looking glasses." She points to her own face and makes a ghastly expression, as if she has been forced to wear them. "What did you do to them?"

Jack touches the fingers of his left hand to the frames of the black glasses and shrugs. "I don't know. I've broken them a few times, I guess. I was wearing them when I had my last bike accident."

"Oh. Well, I think they're pretty awesome. In a fucked-up sort of way."

Jack nods, unsure what that compliment actually means. His glasses have never felt so awkward on his face. He pushes them up against the bridge of his nose. And then he does not know what to say after that. He looks down into his coffee, and then checks his watch, and then looks down at his coffee again.

"So," he says.

"So."

"So," he repeats.

"I'm kinda seeing someone. I think I ought to let you know."

"Okay," he says, feeling his face crash and twinge in an expression of disappointment he knows he is unable to hide.

"We're not really talking at the moment. But still."

"Okay."

"In case you had any ideas."

"I don't have any ideas," he says, the falseness of the words hanging in the air with their dismal tone.

"What about you? Are you seeing anyone?" she asks.

And he thinks and looks down at his empty left hand, his empty ring finger, and says, "No."

"Oh."

"Yep."

"So, do you want to go to my place and hang out? We can watch a movie. I have almost all of Truffaut's work on video. Have you ever seen *The 400 Blows*?"

"You want to go to your place?" he says, the shock of the question nearly knocking the slumpy glasses from his face.

"Sure. Why not?"

"Okay."

And so they do, Jack riding his blue ten-speed behind Odile, watching the way the ends of her dark hair flit out from under her winter cap like wings. And they are riding past the small hillocks of snow and ice and everywhere there is music, the softening key of pink and silver lights.

AT HER APARTMENT.

Jack helps Odile carry her bicycle up the snow-fjorded stairs, each of them taking a wheel. And then he runs down and gets his blue ten-speed. It is almost two a.m. now. And he can see a series of white footprints trailing past the moldy carpeting of the third-floor landing where Odile is searching her parka for her keys. "Just a sec," she says, and leans up against the door. "We have to be quiet. My roommate works mornings," and in they go, the apartment sparsely decorated, Jack taking in the garage-sale furnishings—the antique though very modern-looking lamps, the poster of Serge Gainsbourg—and then he parks his bicycle beside hers across from a brass-colored radiator. And the way Odile stands there, watching him take off his wet shoes, it is like they have done this together a million times before, her leaning there, smiling, her face ruddy, cheeks pink from the cold, arms folded across her chest, waiting, not impatient, but waiting, as if the two of them already know each other, and have already spent countless nights together. And he walks across the apartment in his damp gray socks and bumps into the couch and Odile laughs and whispers, "Shhhh," and it's like they're kids, like this is only a game, just some practical joke.

BUT THEN SITTING ON THIS GIRL'S BED.
Instead of beginning to kiss each other savagely, instead of
undressing themselves with that random sense of urgency,
they sit beside each other quietly, Odile with her legs folded
beneath her, Jack with his two feet on the messy floor, articles
of clothing and books and vinyl record albums strewn about in
a performance piece of absolute messiness, and what Odile
does then is take out photo album after photo album, turning
the plastic-coated pages, pointing at people Jack does not
know.

"This is my dad," she says. "Before he shaved his beard.
Now he looks like a newscaster. He used to be a pretty famous
artist. My mom's an artist too. They do these amazing woodland
scenes in oil. Hotels have their stuff all over the country."

Jack nods, sees the rugged face, the conservative smile.

"This is my mom. This must be back in the '70s. Or maybe
the '80s. I can't tell. Look at those earrings."

And here Jack can see the same neck, the narrow
litheness, and he nods.

"Here's my grandma. She's probably my favorite person
in the world."

And her grandmother is sitting on top of an older man's
lap, the two of them wearing paper party hats. "That's one
of her boyfriends, Hank. She has three of them. Boyfriends, I
mean. And two of them are named Hank."

"She looks like she knows how to have fun."

"She does. I spent all of my summers with her, growing
up. I have five brothers, so in the summer my parents let me

go live there with her. She lives just outside Minneapolis. That's where I'm from. Minneapolis, I mean."

"You're from Minneapolis?"

"Yep."

Jack looks at her and smiles, surprised for some reason. "You don't look like it," he says.

"What's that supposed to mean?"

"I really don't know," he quietly admits. He looks down at the photo album and asks, "Who's that?" He points to a teenage boy with a long dark mullet.

"That's my oldest brother. He's in jail now."

"Oh."

"Yeah. We don't hear from him much."

"Who's that guy?" Jack asks, pointing to another young man with a mullet, this one with a long scar running down the side of his face.

"That's Randy. He's my brother too. He's the second oldest. He was in a motorcycle accident when he was sixteen and hasn't been the same since."

"You have five brothers? And you're the only girl?"

"Yep. Four older, and one younger. The older ones are all a mess. My younger brother, Ike, he's still in high school. He's having a hard time of it right now but I think he's going to be okay. My parents, they kind of didn't believe in rules. They're creative-types, you know, hippies, so ... my family is all a little nuts."

"Do you miss Minneapolis?"

"Who me? No way. I mean I do. Not the people. But the place. When I was in high school, we used to get drunk and roam around the Skyway. That's in St. Paul."

"What's that?"

"The Skyway. It's like this thing. This thing that connects all the buildings downtown because it's so cold. You can get

around without going outside. The Replacements have a song about it."

"I don't think I ever heard it."

"Oh. Well. That's basically the only thing I miss. The Skyway. That and my parents. And my grandma."

"Oh."

"Yep."

And she nods, looking down at the red polyvinyl photo album again.

"Hold on a second," he says, and digs into the pockets of his gray parka. He finds the silver tape recorder in the left pocket, checks to be sure there's a tape in it, and then points it at her.

Odile looks down at the silver recorder and frowns. "What's that?"

"It's for this project I'm working on. Do you mind me asking you a few questions? Imagine you're a television star and I'm a television reporter."

"What project?"

"Just this thing. All you have to do is be yourself and just answer the questions."

"Okay," she says, rolling her eyes a little.

"Okay, the girl from the office," he announces directly into the recorder. "Okay. First name and age."

"What?"

"Um, your name, and then your age."

"Okay," she says, leaning forward. "Odile, twenty-three."

"Okay. Shoe size?"

"Seven and a half."

"What famous person would you be and why?"

"I really don't like famous people."

"Try again."

"Okay. Superman's girlfriend."

"Really?"

"Really."

"Okay," he says. "Do you have any distinguishing features?"

"I have an overbite. And my shoulders are kind of narrow."

"Okay. What crime have you committed recently?"

She pauses and then says, "I slept with a married man."

And Jack looks down at the tape recorder, making a surprised expression, eyebrows tilting up. "Really?"

"Really," she says. "I'm not proud of it. But it just keeps happening."

"Okay," he says, feeling his heart sink a little. "Okay. Well. Here's a tough one: Do you think I have a big forehead?" he asks. "Or is it perfectly proportioned?"

"What?"

"My forehead. Is it too big? Or is it just large enough to be called handsome?"

"No. It's okay."

"It wouldn't prevent you from going out with me?"

"What?"

"Nothing."

"Duh," she says.

"Okay. So what do you think of telephone sales?"

"I've done it before. For a couple years. I don't mind it. But I've actually been thinking about moving to Greenpoint, in Brooklyn. I have a friend out there and she said I could stay for a while, until I get my own place. Our lease is up at the end of the month and my roommate is a little nuts and so I'm thinking about going to New York. I just don't know. It's so big and I don't want to get swallowed up."

"Oh," he says, feeling his heart sink again. He switches off the tape recorder and stares down at it, then shoves it back into his coat. "Well, I've never been to New York, but I hear it's for assholes."

"It's not."

"Well, that's what I heard. Cool people don't live there anymore. They all live here. In Chicago."

"Yeah, right," she says, smiling larger than he has seen her smiling before, a dimple peeking out along her left cheek.

And here he smiles, seeing her smile, and pushes his glasses up against the bridge of his nose and says, "I was thinking. Do you mind me asking how you spell your name? Because I don't think I've ever heard it before."

"Odile. O-d-i-l-e. It's my grandmother's name. Which is maybe why I like her so much. We're kind of like twins."

"It's a really great name."

"Really? I don't know. My brothers, all of them have these really boring names. And for some reason, because I was the only girl, my mom decided to get creative. So ... I dunno. I used to hate it. I used to get teased about it all the time in grade school."

"Yeah."

"I tried to get my parents to change it. They told me I could if I wanted. So I started signing my name on my papers at school as Jennifer. And sometimes Kelly."

"So they let you change it?"

"Yeah, I dunno, they were really weird like that. They once took us all to the Empire State Building because one of my brothers was doing a history project about it."

"That's really nice."

"I like them okay."

"So did you change it back? Your name?"

"Yeah. I don't know. I guess I realized at some point it didn't matter what my name was. People still thought I was the same person. And anyways, like I said, I really love my grandma, so I got used to it."

"I never knew any of my grandparents. They were all dead before I was born."

"That's too bad. My grandma, she used to give me a little glass animal every year for my birthday. You know, those little pink glass animals? I still have them. Most of them are broken but I still have about five or six of them."

"Which is your favorite?"

Odile pauses here, thinking. She stands up and then crosses over to a small desk and lifts up a tiny pink animal, made entirely of glass. She hands it to him.

Jack stares at it, at the odd angles of its joints and limbs, and asks, "What is it supposed to be?"

"A unicorn."

"A unicorn? Where's its horn?"

"It's broken off. It broke when I moved here."

Jack looks down and sees, on the animal's head, a small rough circle where the horn was once attached.

"So why's this one your favorite?"

"I don't know. I like it better now that it's broken. It's kind of down on its luck. It seems more realistic for some reason."

Jack nods and hands it back to her. Odile sets it down on her desk and then returns to the bed. The two of them sit beside each other on the bed for a long moment, the sound of the radiator in the other room ticking off the seconds of their stilted breaths. Odile hums a little something to herself and then sighs.

"So," she says.

"So."

"So."

"So are you really seeing someone right now? Or did you just say that so I wouldn't try anything?"

Odile nods and then shrugs her shoulders. "I mean, he's not my boyfriend or anything. We're just seeing each other. We never talk unless I call. It's kind of over, I guess."

"It is?"

"It is. So what about you? You're not seeing anyone?" she asks.

"No, I'm ... I'm kind of going through a divorce right now."

"Kind of?"

"I'm definitely going through a divorce right now."

"Wow. How old are you?"

"Twenty-five. Almost twenty-six."

"And you're already divorced?"

"Yep. That's one life goal already crossed off my list. And I feel pretty good about it. Not really. Actually, I feel pretty bad about it."

"That sucks."

"Yeah."

"So," she says, "what happened?"

"I don't know. Maybe we can talk about it some other time. It's kind of complicated."

"Okay," she says. "So do you want to see something amazing?"

"Sure," he answers, smiling at her giddiness.

She leans over and reaches beneath the bed and pulls out an old-looking comic book, *Abstract Adventures in Weirdo World*, and hands it to him. Jack smiles and begins to slowly turn the pulpy pages, taking in the weird geometric shapes, the absurd juxtapositions of body parts and animals.

"What is this?" he asks.

"It's a comic book I found. I got it at a garage sale a couple months ago. It's by this guy Frank Porter who I never heard of."

"It's pretty psychedelic."

"Yeah, I think this one is from 1974 or so. I went and looked him up in the library. Apparently, he made all these comics just to amuse himself. Because he couldn't be around people. You can see he was totally into R. Crumb's style. It's so trippy and globular-looking. I think this was like a year or so

before he stopped making comics. He was only like twenty-four, twenty-five. And then he just gave it up and became a janitor."

"Wow."

"But he drew hundreds of these comics before he stopped making them, and then, after he died, his sister found all of them. I think he ended up hanging himself. I'm pretty sure this is actually kind of valuable now."

"Hmmm," Jack says, inspecting a panel of a triangle with arms, lighting what appears to be a joint.

"It's funny. I think about him a lot. Like how old people are when they give up, you know? Like before you just accept that your life is going to be the same as everybody else's. Before you do anything great."

"I don't know," Jack says. "I think about that a lot too." He flips to another page, seeing a pyramid of silver lines, which upon closer inspection reveal a nude female shape. "These are really weird."

"I know. And nobody knows about him. He's kind of my biggest influence. As an artist, I mean. Him and my dad."

"Your dad?"

"Yeah, because he works all the time. At first I thought making hotel paintings wasn't cool. But now I think it's pretty great. It's all he does all day. And people actually see what he makes. Even if they are kind of bland. I mean, the other thing is that when I was a kid, my dad had all these art books and everything, lying around, and he would explain them to me. Like Magritte. And Gauguin. I know the reason I want to be an artist is because of my mom and him."

"That's pretty cool. My father's a shrink. We didn't have any art books lying around when I was a kid. The only cool thing we had growing up was the DSM, which lists all the things that can go wrong with your head. That and The Joy

of Sex. But I don't think either one of my parents ever opened it. They got divorced when I was like five or so. And then she got remarried. To another shrink, this guy David. He's pretty great actually. I kind think of him as my actual father. He's the person I call if, you know, I'm ever in trouble."

"That's nice you get along with him."

"Yeah. But then my mom divorced him too, when I was like eight or nine. And then she married some dentist. But we still talk. My first stepdad, David, and me."

"My parents are so weird. They're still like teenagers around each other. They still like holding hands. They still smoke a lot of dope, though."

"That's great."

"Yeah." And then they both look down at their feet for a few seconds before Odile asks, "So, do you want to see this thing I've been working on?"

"Sure."

Odile stands up suddenly and snatches a small green pad from her bureau and then hands it to him. "It's this notebook I've been putting all my ideas in. They're more concepts of projects than actual projects. Kind of like Yoko Ono."

Jack nods and flips through it. There are small pencil sketches, quick drawings, and lists. On one of the lined pages it says, *Dress like a ghost on the bus.* Beneath that it says, *Buy some parakeets and turn them loose in front of a playground,* or, *Act out a scene from a famous movie on the subway,* or, *Create a banner for some nonexistent event,* or, *Put on a puppet show in a hospital emergency waiting room.*

"These are really great," Jack says, smiling.

"Yeah, I dunno. One day I'm going to do them all. Right now I'm just coming up with different ideas. I feel like ... people in this city ... nothing surprises them anymore. When you live here, there's just too much going on around you, so you don't

see any of it. It's hard to get people's attention. Unless it's something bad, like a murder or natural disaster or something. Because nobody in this city is surprised by anything."

Jack nods and looks away for a moment.

It's late, it's begun to finally feel late. The streetlamps outside the window have started to shine in a way that suggests that the sun is only an hour or so away from coming up. Odile yawns, covering her mouth with the back of her hand in a polite fashion that Jack thinks is really pretty adorable.

"I guess I should get going."

"You can stay. If you like. I mean, not to fool around. Just to sleep. Like I said, I don't sleep with people unless I know them pretty well."

Jack thinks about how cold it is outside, of his bicycle, and the snow, and then sees this girl and her narrow but warm bed, and says, "Okay. If you don't mind."

Odile nods and then pulls off her gray sweater, and she has a soft white T-shirt underneath, which traces the angular shape of her thin frame, and she is unbuttoning her pants but without standing up, which Jack finds pretty fascinating, and then this girl, this person he barely even knows, is in her white underwear, which Jack cannot help but stare at, and she is diving under the blankets, and Jack does not know what to do with himself, and so he unbuttons his shirt and decides to leave his pants on, and he begins to climb under the blankets, and she looks at him and says, "You can take off your pants," and he nods, and turns around, and wonders what kind of underwear he has on, and he is secretly glad they are boxers, and relatively clean, and he feels an erection beginning to come on, and so he hurries beneath the comforter and sheets, and she turns away from him then, facing the wall, and there is her shoulder, and the shiny strap of her nude-colored bra, and freckle after freckle along her long neck, and he does not

know if he should say something or do something else, and so ceases to think, only lies there, and in the absence of thought he listens to the girl breathing, and she turns her head toward him a little and says, "Goodnight," and they sleep like that together for the first time without really touching each other, but the feeling is enough, at least for now, the inexplicable thrill of someone being beside you in a strange bed, and all that it might mean.

AND AT EIGHT A.M.

He wakes up with a crick in his neck and the girl, Odile, is still sleeping pretty soundly and so he climbs out of the bed and finds a black magic marker on her bureau and writes his phone number on the lower part of her narrow back. Her nose twitches a little as he does it but otherwise she doesn't even seem to notice. *Now she can call me or not call me*, Jack reasons, dragging his bicycle out into the snow. *This way it isn't up to me at all*.

And there, outside her apartment, is a yellow sparrow barking in a gray tree limb, and he records five seconds of that.

AND AS HE RIDES.

He decides the next time he's alone with her he will put his tongue in her ear. Or something.

Really?

Maybe. Because he's got to try. Because she is too interesting, too beautiful not to even do anything.

And he doesn't want to go home and go to sleep. Because he knows he won't, he knows he can't. So he rides around, taking out his tape recorder, capturing the noise of different kinds of light.

A STREETLAMP.

A HEADLIGHT.

A NEON SIGN.

Each of them different.

And then he gets some coffee and rides to the Lincoln Park Zoo and runs around recording the sounds of different animals, the lemurs, the gibbons, the birds. And what he really wants is the sound of a tiger. But it's just lying there on top of some fake rocks, sniffing at the snow. And so he waits. He leans against the metal railing for about a half hour or so and finally, when the zookeeper opens the gate and throws in a dripping red hunk of meat, the tiger lets out a loud roar, the kind of roar from a jungle movie. It's perfect. And Jack gets it on tape. It's probably only three or four seconds long but that's okay. And then he is unlocking his bicycle and riding home and then it's starting to snow again. And wow. It's really coming down again, like a cartoon, like it's the idea of snow, like it's not even the real thing. Everything is white and soft and

dazzling. And Jack, in front of his apartment building, can't help but stop and record as much of it as he can. Because it's a marvel, an explosion, a cyclone of white and silver flakes.

OPENING HIS APARTMENT DOOR.

Jack apologizes to the gray cat, who he has decided he will rename, though he hasn't come up with an interesting one just yet, and so he feeds it and then goes about the business of dating and labeling the minicassettes he has just made. When he is finished, he stands beside the narrow card table on which the answering machine sits, sees there are no new messages, and then, feeling more lonely than he'd like to admit, he presses the play button. He hears Elise's voice, the confident lilt as she announces, *"Hi, we're not in right now ..."*

We, us, we, he thinks, as he watches the small tape unwind itself. It's been almost a month now and he hasn't changed the answering machine message. Not because he hasn't wanted to, but because he knows he can't. So he presses play once more, notices the way Elise says, "Hi," like she is just meeting you for the first time, and then he stares down at the device, thinking about taping over the message, realizing then that it is one of the few recordings he still has of Elise's voice. *No,* he thinks. *Give it another week and then I'll do it.*

A few moments later the phone rings and Jack is so sure it's Elise calling that he doesn't wait for the machine to pick up. He holds the phone against his ear, almost forgetting to say hello.

"Jack?" It's a man's voice, his stepfather's voice, David.

"David?"

"How are you, kiddo? I wanted to check in and see if you got your tooth fixed."

147

"Not yet. I need to make a follow-up appointment."

"Did you go and see Ray?"

"I did. But he wasn't in."

"Do you want me to call him for you?"

"No, no, I've just been busy with other things."

"I was hoping you and I could go get some lunch sometime."

"Sure," Jack says, scratching his arm. When was the last time he saw his stepfather? Six months ago? A year ago? He can't even begin to remember.

"How's this week look?" David asks.

"Okay. Whenever you want."

"I'd like to talk to you about a couple things. How about this Friday?"

"Are you okay?"

"I'm fine. Just a few things I need to talk over with you."

"Okay."

"So how's this Friday at Gene and Georgetti's?"

"Okay. Are you sure everything's okay?"

"Everything's terrific. I'll see you then. Don't be late."

"Okay."

And Jack hangs up the phone and sits and wonders what could be so bad that his stepfather wants to see him.

Later, he takes a seat on the floor, and the cat, who he has now decided to call Jacques, takes a seat beside him. Together they listen to the new cassette tapes, Jack rewinding the one of Odile from the previous night, studying the soft timbre of her words, the raspy tremor of her unfamiliar voice. He rewinds it a few times, surprised by her weird answers, as Jacques the cat purrs softly in his lap.

NEITHER ODILE NOR JACK KNOW WHERE TO LOOK THAT NIGHT.

Anonymous-seeming stares which wander past the water cooler to the soft hazy spot at the back of the office girl's neck as she stops to sip a paper cup of water, and then crushes the paper cup in her hand, and then his glance moves down to her bare knees, then to the hem of her soft, fluttering gray skirt as she walks back and everyone—meaning Gomez and the other two operators and maybe even the nighttime cleaning ladies—has to notice him staring. It's weird for everybody that Wednesday night. Because Jack and Odile don't know where to look when they pass each other coming out of the break room or when, leaning back in their office chairs, they happen to have a moment of eye contact. Because ideas have begun to make themselves known. Ideas concerning inappropriate, unprofessional, and imagined actions between members of the telephone sales department who were previously thought to be only work-related acquaintances, and near strangers at that.

Until finally, standing before the vending machine, in the quiet disarrangement of the break room, Odile leans over and whispers in Jack's ear, "Do you know where I can get a bunch of cheap balloons?"

"What for?"

"It's for this thing I'm working on."

"What thing?"

"This thing."

"I guess. There's this one place on Chicago Avenue. It's

a party store. You can probably get a bunch there for cheap. Why, what's it for?"

"It's for this project I'm thinking of doing."

"I could help. When are you going to do it?"

"Tomorrow."

"I'm not doing anything tomorrow."

"Okay," she says, smiling, though not looking at him. He sees her soft reflection in the plastic window of the vending machine and then looks away quick.

Before she turns to head back to her desk, Jack pipes up: "I wrote my phone number on your back."

"What?"

"I wrote my phone number on your back."

"You did? Why would you do that?"

"I don't know. I thought it'd be funny."

"I didn't see it. And then I took a shower."

"I kinda thought you might not. It seemed like a good idea at the time."

"Yeah."

"Yep, but it really wasn't," he says, looking down at his feet.

"If you wanted to give me your number, why didn't you just give it to me?"

"I don't know. I didn't want you to get the wrong idea."

"What idea?"

"I don't know. I just thought ... I don't know. I wanted you to have it. I mean, I like hanging out with you. But I didn't want you to think I was a weirdo or something."

Finally, Odile turns and faces him and says, "Too late for that," and then winks at him and heads back to her desk. And he stands there and thinks he can still smell her powder deodorant, the oddly attractive oil of her hair, lingering there like some phantom castle.

AN ACT OF ART TERRORISM.

At nine-thirty a.m. that Thursday morning they meet up outside the party store on Chicago Avenue and Odile buys fifty silver mylar balloons for only ten bucks and Jack asks, "So what's the big idea?" and Odile asks, "Are you in?" and he says, "Sure, why not?" and Odile holds the silver balloons as they ride downtown to a small office building with large rectangular windows, and then they lock their bicycles up out front.

"Where are we going?" Jack asks, and Odile just winks and they walk in through the revolving glass door, and the balloons get stuck at first, and then they make it past, and Odile flashes a small ID card of some kind and the overweight guard looks up at her suspiciously, and she says, "They're for someone's birthday," and he nods, his jowls shaking, going back to his mangled newspaper, and Jack follows closely behind, and Odile whispers, "I used to work here, doing telephone surveys. I really hated it," and Jack shrugs and they stand before a bank of elevators and Odile presses the up button, and together they silently wait, and when one of the elevators arrives, and the mechanical doors stagger apart, the two of them step inside, forcing the balloons to fit.

"Okay," Odile says, and from her bag she removes two cloth ski masks: a black one and a red one.

Jack stares at them and shrugs.

"Which one do you want?" she asks.

"What are they for?"

"To be anonymous."

"I'll take the red one, I guess," and he reaches out for it, removing his glasses, putting the ski mask over his face. It is a little too tight and he can feel it digging into the back of his head. Also, it's hard to see or breathe through the narrow holes. And so he puts his eyeglasses back on over the mask and imagines how ridiculous he must look.

"Now what?" Jack asks, and Odile smiles a coy smile and then fits the black mask over her face. She actually does look like some kind of art guerilla. She takes out a silver paint pen from her parka and, on the smooth wood-paneled wall of the elevator, she writes: *ALPHONSE F. WAS HERE.*

"What's that supposed to mean?"

"It's our slogan."

"Oh." And then: "Who the heck's Alphonse F.?"

"He was a boy I went to elementary school with. He was this short, kinda dirty-looking kid. He used to get in trouble all the time in art class for drawing naked ladies. But he'd always put his name in the corner of the drawing, just like that. *Alphonse F.* And then he'd try to sell them to other boys in school. I've been thinking we should name our movement after him. Because he was the first great artist I ever met."

And Jack looks at the silver writing on the wall and sees the bustling silver balloons and sees the black ski mask over Odile's face and decides there's little to do but agree.

Without them pressing any buttons, the elevator begins to ascend and eventually stops at the sixth floor. A matronly woman in a beige dress climbs aboard. She looks at two young people in ski masks, sees all the silver balloons, and then looks down. No one says a word. She climbs out of the elevator on the fourth floor, looking over her shoulder once more, to be sure of what she has seen, and then the mechanical doors close behind her. The two young masked people both begin to laugh. The elevator makes it to the lobby

without any other stops. Once in the lobby again, they take their masks off, Odile tugging Jack by the sleeve, the two of them pacing themselves, trying to walk out as unobtrusively as possible.

Back in the cold air, the wintry snow flying before them, Jack squints over at Odile and asks, "So what was that all about?"

"What do you mean?"

"I mean, like what was the point of that whole thing? With the balloons and masks and everything?"

"There's no point. It's just something to make people think."

"But what are they supposed to think?"

"It's just something, like a puzzle, for people to think about. It doesn't have some grand meaning or anything. It's just like a moment to be surprised by something. Kind of like a daydream. But something ... real."

And Jack nods and suddenly thinks she is a lot smarter and more interesting than he had thought before. Odile finishes unlocking her bicycle and is pulling her pink mittens back on and she can see him staring at her, wanting to say something else, maybe wanting to kiss her, and so she puts him out of his misery and asks, "So. Do you want to get some pancakes?"

"Sure."

Because, now, what else is he going to say?

ABOUT THESE PANCAKES.

These pancakes are served at a corner diner on Damen and Chicago, a few blocks away from her apartment. Jack gets blueberry. Odile gets chocolate chip. The pancakes are huge and perfectly circular and come with tiny butter squares. They are eaten in near silence until Jack is caught staring at Odile's pancakes in a weird way and then she finally asks, "What? What is it?"

"Nothing."

"You don't like chocolate chip pancakes?"

"No."

"Have you ever tried them?"

"Once."

"Well, I love them."

"Yeah. They give me a bad feeling."

"How come?"

"I don't know," he says. "It's weird."

"Really?"

"Yeah," he says. "It's a little too personal for pancakes."

"What's that mean?"

He sighs and says, "My first stepdad, David, he always used to take me and my older sister to dinner. Once a week. It was like our night out with him, and he'd try to get us to go to these fancy places, but all we ever wanted to go to was to the International House of Pancakes. And so he'd take us. But he wouldn't ever let us order chocolate chip pancakes."

"Why not?"

"I don't know. Some hang-up of his. He's a shrink, and

Jewish, so who knows? Maybe they were too unhealthy. Anyways. This one time he takes us out and asks where we want to go, and we say, *International House of Pancakes*, and he takes us and we're sitting there and we ask if we can order chocolate chip pancakes and this time he looks at us and says yes and so we go crazy. And then they come, and they're like covered in whipped cream and there are cherries and it was all made to look like a smiley face. You know, like there were these two smiley faces sitting there and so we started eating them. And then my stepdad looks at us and coughs or something and says, *Your mother and I. We've decided to get a divorce*, and I could feel the chocolate chips get stuck in my throat, and I look over at my sister and she looks over at me, and then we look down at the pancakes and they have those stupid chocolate smiles, and neither of us wants to finish, because we feel so bad, but I kind of feel like this is my only chance, and so we keep shoveling these stupid pancakes into our mouths, but we don't even enjoy them. That's like my one childhood memory. Even then I guess I couldn't finish anything."

Odile glances down at her pancakes and frowns. "Why did you tell me that?"

"I don't know," he says.

Odile sets down her fork and knife. Jack shrugs and finishes his.

"What were you like when you were a kid?" he asks.

"I guess I was weird," she says. "I used to try to break my arm all the time."

"Really? Why?"

"I don't know. It's probably because I have five brothers. Almost all of them are older. So the only way anyone ever got any attention was to break an arm or a leg or something. And I guess my brother Dave broke his leg one summer and he got to sit in this lawn chair and ask for things and my mother

would bring them to him, and so the rest of that summer I tried to break my arm on things. I would like fall out of trees or like slam it in a door or something."

Jack smiles. "That's so weird. It's perfect."

"Yeah."

"That's what you remember from being a kid?"

"No. I mean there's other things," she says. "It seemed like it had something to do with your story but I guess it really doesn't."

"That's cool."

"It's funny though. It's like part of the problem I still have. Even when I was a kid, I wanted everyone to notice me. To like me. People really don't change all that much, do they?"

"Maybe only every so often. Or if something really big happens. I still think I'm pretty much the same I was when I was ten years old. I still like the same stuff. Books and music and movies. It's weird to think about."

And she nods. "I'm totally that kid still trying to break her arm."

And then the bill comes, and each of them pays exactly half.

And then they are walking down Damen Avenue, Jack pushing his bicycle, Odile tromping ahead with her own bike, following a narrow path through the ankle-deep snow which has been stamped down by other people, and Odile is about a foot ahead of him and he just then notices she has her funny white hat on, with a small ball at the end, and it looks like it might be something she crocheted herself, and then she is leaping over a murky gray puddle, and pausing before a poster announcing some new brand of jeans. And Odile already has her silver paint marker out and is writing, *ALPHONSE F. IS NOT INTERESTED,* and then she has capped the pen and is walking on again. Jack glances at what she has written and

then follows her, feeling the cold attack his hands, and so he curls them up into his pockets. Is he following her back home? He doesn't really know. She isn't talking and they are walking in the cold and Jack can see his own breath and finally he says, "So are you heading back home now?"

And Odile turns, and her wide cheeks are pinkish, and she gives him an annoyed look and says, "I thought you were coming with," but when she says this, he notices she is not looking at him, and his heart is choking him all of a sudden, and she is skipping over another puddle and then she asks, "Is that cool?" And then he says yes. Most definitely.

BACK AT HER APARTMENT.

Before they get their bicycles in the door, Jack is already thinking of how he can try to put his tongue in her ear. The apartment is quiet but full of light and it appears that her roommate has gone to work but has left a half-eaten bowl of cereal sitting there on the sofa, and Odile looks at it and shakes her head and says, "You can see why I'm moving out," putting the dish in the sink which, hearing her mention moving again, makes Jack feel slightly bad. Odile unzips her coat and kicks off her boots and Jack doffs his winter hat and the two of them sit beside each other on the couch. And then Odile leaps up and puts a record on and it's a band he's never heard of, King Missile, and he asks who it is, and she tells him, and he nods like he knows, and they sit beside each other again, Jack staring at his wet socks and then hers, and she is singing along and Jack thinks that if he doesn't try to kiss her something in him might explode, but instead he reaches into his coat and takes out his silver tape recorder and hits play and record and holds it before their mouths and asks, "Question Number One: what is your favorite song of all time?"

And she says, "I don't know. I don't think I have one. I like a lot of different types of music. It kinda depends on my mood. What about you?"

And he holds the microphone under his chin and says, "I guess I would have to say 'The Umbrella Man' by Dizzy Gillespie."

"I don't know that song."

"Do you know who Dizzy Gillespie is?"

"Yeah, I know who he is. I just don't know that song."

"My stepdad, David, he loves music. He's like an amateur record collector. He'd always play a different record during dinner: jazz, Motown, folk. We used to do this crazy dance together to that song 'Umbrella Man.' And then at night, he'd play a record for us as we were going to sleep, my older sister and me. Sometimes it would be a doo-wop record or maybe some jazz. But I used to love it, it made me feel safe, you know? It's funny. Everything I know about music I learned from my stepdad."

"That's great."

"Well, what about you?" he asks. "Did you come up with a song yet?"

She squints and says, "How about 'After Hours'? By the Velvet Underground."

"Very nice. You must have gone to art school."

"I did. For a while anyway."

"What did you go to school for?"

"I was in painting. And then a video major. And then painting again. I couldn't make up my mind. I wanted to try everything. But I wasn't really good at any of it."

"I was the same way. I still haven't figured out what I want to do."

"I'm pretty sure it's not working in an office," she says. "I don't think I could live with myself, doing the same thing every day. It's okay for now. But I really think I need to move at the end of the month and try something new. I feel like if I don't do it now, I never will."

"I don't know," Jack says. "I kind of like it. Working in the office, I mean."

"You do?"

"I really do. It's the first time I don't have to think at work, you know. It's really simple. You just answer the phone and

put in people's orders. It's pretty laid back. You don't like it?"

"No. I feel like it's killing my brain."

"Maybe that's why I like it. I don't mind not having to think."

"Really?"

"Really," he says, looking down at the tape recorder. "So. Okay. Question Number Two: if someone you loved was disfigured in a car accident, would you still love them?"

"Yes, but I would hope they would leave me."

"What?"

"I think it would be too hard on the other person, the normal person. If I was in love with someone who got disfigured, I'd hope they'd leave me."

"Wow. All right," he says. "Okay. Question Number Three: what's the worst thing you ever did?"

"What?" she asks, grinning at him.

"What's the worst thing you ever did?"

"I don't know if I want to answer that," she says.

"It's part of the interview. Don't be a chicken."

"I don't think I really want to talk about it," Odile says again.

"No?"

"You go first," she says. "Then maybe I will."

"Okay. I was maybe eight years old. I pushed this boy into a pool and he couldn't swim. I mean, I didn't know he couldn't swim. I was there with my sister and my stepfather at this club. It was just before my mother divorced him. And my stepdad was excited that we'd be allowed to join the club, because he's part Jewish, and there weren't any Jewish people in the club. He's only half Jewish but he considers himself Jewish because his mom was. I dunno. Anyway, we were at the pool. And this boy I didn't know was pushing my older sister, and then he pushed me and so I pushed him back and he fell in. But he

couldn't swim because he was retarded. I didn't know he was, I just thought he was big and mean. And I didn't figure out what happened until after it was over. The lifeguard got him out but he was really screaming. I'll never forget the sound of him screaming. It sounded like a baby crying. Then we were asked to leave the club. My stepdad was mad at me for the rest of the summer. And then they got divorced. I know it didn't, but I always felt like that had something to do with that."

"That's pretty bad."

"Yeah, I know. It is pretty awful." Jack scratches his nose. "What about you?"

"What is the worst thing I ever did? I don't know. I cheated on this really nice guy a few years ago. When I was a freshman. And then, a few months ago, I gave a handjob to this guy I worked with and he went and told everyone in the office, and so I had to quit. I don't know. I keep doing weird stuff like that. It's gross. I don't really know what's wrong with me."

"Oh."

"I don't even know why I do it. I mean, I didn't even really like the one guy. I just do dumb things sometimes so people like me."

"Oh."

"Don't get excited or whatever. I'm not gonna give you a handjob or anything."

"What? No. I didn't think that."

"Yeah right." Odile blushes a little and then looks back at him with a slight frown.

"Okay," he says, tilting the tape recorder toward her. "Question Number Four: do you ever get depressed?"

Odile smiles. "I don't know. I guess so. I think it's natural. I think you'd have to be an idiot not to. I mean, it's pretty weird out there. I'm pretty sure the world is going to end in a year and everything."

"It is," he says in full agreement. "It really is."

"And even if it doesn't," she says. "It's only a matter of time anyway."

"That's how I feel. I get depressed sometimes."

"I get depressed because I haven't made anything I'm really proud of in a long time. So that gets me upset. Other things too. I don't know."

"I know what you mean," he says.

"Everything I've ever made seems so useless. Or small. Or insignificant. But I go to these gallery shows and make fun of other people's stuff anyway. I think I'm pretty mean-spirited when it comes down to it. That's why I stopped going to art school. I just felt so mean all the time. It was frustrating. I didn't like what anybody else was doing and they didn't like what I did. I made this painting for my class one time and I worked my ass off on it and everyone kind of ignored it. If they hated it, that would be one thing. But the professor, well, he just ignored it, like it wasn't even worth discussing. So it stopped being fun. And then I didn't want to go to class. I only have like two or three classes left to take. That's it. I could still graduate but I don't think I will. It just seems, I don't know ... Everything people made just seemed so mediocre. Like it was supposed to be shocking or something but it wasn't. I mean, like there's all these movies and TV shows and books now and it all seems so dumb, you know? Like don't you think it's weird that everything has to be a movie now? Like that's all people can understand. Like that's the greatest thing in the world, a big loud movie. But it isn't. Because most movies are pretty dumb, like they mostly make them for dumb people now. Because people are too ignorant to read or go to a museum or something. And it's exactly like what's wrong with the radio. It's like ... anything that tries to appeal to everybody always ends up sounding so cheap. Like pop music or blockbuster

movies. And I don't know. I get discouraged. Because I don't make things that could be turned into pop songs or blockbuster movies. I like to make things that are weird or small. I like things that don't make a whole lot of sense to anyone but me. At the same time, I get depressed if everyone doesn't like what I make. It's weird."

Jack nods, switching off the tape recorder.

Odile stands, brushing her bangs with the fingers of her left hand, and walks over to the window. "It's still snowing. It's been snowing for practically two days straight. I think I'm going to have to take the bus to work tonight."

Jack rises to his feet and stands beside her, parting the shades with his hand. "Wow," he says, seeing the parked cars on the street slowly losing their shapes. Below there is only a field of soft white.

"It's like being on the moon," Odile says.

And they stand there like that, watching the snow for a few moments, not moving. And then he can feel Odile looking at him, staring at the left side of his face.

"What is it? What's wrong?" he finally asks.

"Did you know your one ear is smaller than the other?"

He nods and smiles, touching his left ear. "Yeah. It's weird. I had an infection in my left ear when I was younger and it stopped growing. That's the same size as it was when I was four."

"It's one of the best things I have ever seen."

"Really?"

"Really."

"I always thought it was kind of funny-looking."

"No. It's perfect."

And then she leans in beside his left ear and whispers, "Shhhhhhh."

And he blinks. And smiles wetly.

"Can you hear that?" she asks.

"Yes."

And then she leans close again and says, "We are the only two people left in the world. Did you hear that?"

"Yes."

"We are the only two people left."

And Jack does not know where to look or what to do and it feels like they are about to kiss, but nothing is happening, and then she looks away and says, "I should probably get some sleep before work tonight," and he says yeah, me too, and she says okay, see you later, and he says you bet, but what they are saying has nothing to do with what either of them is thinking and they smile at each other and he walks his bicycle into the snow, staring at the world as if the sky, the trees themselves, have just met.

TROUBLE.

Before work, the phone rings as Odile is trying to shave her armpits. (There is no mirror in the bathtub and her mother taught her to shave her underarms with a mirror, so this is what she does every few days, after her shower, wearing a dirty pink towel.) The phone keeps ringing. No one else—neither Isobel nor her boyfriend—is around to answer it, so Odile has to walk over to the phone with her left armpit full of shaving foam, holding the arm over her head. She grabs it on the fifth ring and says hello, and guess what? It's Paul.

"Hello, Paul," she says, sounding not nearly as sarcastic as she would like.

"I was just thinking about you," he says.

"Really?"

"Really. I haven't seen you in a couple weeks. Not since our little taxi ride. I had no idea you were such an exhibitionist."

"It was the one day I was really feeling happy about something."

"It made me pretty happy too."

Odile rolls her eyes. "Paul?"

"Yes?"

"Are you still married?"

"What?"

"Are you still married?"

"Does the answer to that question actually matter to you anymore?"

Odile thinks about it for a moment and then, smiling, she says, "No. Not really."

"Do you mind if I stop by and see you? I'm in the neighborhood right now."

"Really? You just happen to be in the neighborhood?"

"You're not the only person who lives in the East Village, you know."

"I know." She thinks about it for a moment and then says, "You can stop by, but I'm not fooling around with you."

"Fine. I just thought I'd say hi."

"Yeah right," she says, disappointed by how excited she is to see him.

"Great. I've got a surprise for you," he says, and even though she knows he doesn't, she will decide to buzz him up. And then what? She doesn't even know.

ON HER BICYCLE THEN.

Off she rides through the snow at 5:19 p.m., almost twenty minutes late, locking it to a parking meter in front of the narrow office building. There is the chemical green scent of Paul's aftershave all over her neck and hands and lips, which she tried to wash off twice, but now it's everywhere. She lowers her green hood away from her face once she is through the revolving doors and takes the elevator up to the thirty-fifth floor and then finds her way to her small gray cubicle before Gomez can yell at her, and there she finds a small, folded note waiting for her. She picks it up and then peeks over the cubicle wall at Jack, who is doing his best to look busy.

"What's this?"

"Nothing. Just a note."

"Should I open it?"

"Sure. If you like."

And she does, carefully unfolding the slight edges, seeing it is written on a pink phone message sheet. It says:

YOU'RE PRETTY ~~COOL~~ OKAY.

"Wow. Some compliment," she says, smiling. "How long did it take you to come up with that?"

"Well, I didn't want to give you the wrong idea. I mean, *okay* isn't actually all that great. Okay is pretty average, actually."

She nods and says thanks and puts the note into her parka pocket. Is she blushing? It looks like maybe she is blushing. He nods and picks up the phone to answer a call, disappearing back behind the cubicle wall. A moment or two later, Odile's face appears, the expression in her eyes shielded by the glare from the fluorescent lights above.

"I feel like I need to tell you something," she says.

"You do?"

"I ran into that guy I was seeing today. It's kind of weird. But I think we're maybe seeing each other again."

"You are." And his voice sounds outright despondent.

"I think so. Maybe."

Jack does not know what do with his eyebrows, his mouth, his face. "But what ... what happened? I mean, I thought he never called you."

"I know. But then he called. And then we hung out. It's weird but it's nice to be with someone who knows what he wants. Because I know I don't."

Jack nods, his neck feeling stiff.

"But we can still hang out. I just felt like I should say something. I don't know why. I mean, it's no big deal, right?"

"Right. It's no big deal. We were just hanging out."

"Right," she says, and Jack wonders if either of them believe this particular lie. "Well, I should probably get back to work," she says.

"Sure." And he nods and stares at the unringing phone, twisting his hands together, wishing he had something to strangle.

And then the girl, Odile, peeks her head back out from behind the cubicle and says, "I forgot to tell you. I'm doing another project. Tomorrow. Are you interested at all?"

"Maybe," he says. "What is it?"

"It involves finding some old bedsheets. Do you have any?"

"Probably. Why? What're they for?"

And she takes his right hand and on his open palm, in black pen, she draws the shape of two ghosts.

ANOTHER ACT OF ART TERRORISM.

At the bus stop, people crowd around each other, avoiding the snow on that Friday morning. There is an old lady with shopping bags. Two teenage girls in blue-and-gray uniforms waiting to go to school. There is an older Mexican man in a pair of blue coveralls. Among these people at ten a.m., Odile and Jack stand, Odile holding a brown paper shopping bag, inside of which are two long, mostly white sheets. When the Division Street bus arrives, Odile and Jack climb on last, taking a pair of seats near the front that run perpendicular to the rest of the rows of commuters. The other riders are busy reading paperback novels or staring at the dull gray world outside. Before the bus has reached Wood Street, Odile pulls out the two sheets, finding the holes she poked for eyes, and hands one to Jack. The other she pulls over her head. Somebody, somewhere on the bus, begins to laugh. Jack turns his head to hear it. He feels pretty certain someone is going to throw something at him. But instead, Odile, with the sheet over her head, places her hand beside Jack's, and they sit there, holding hands, two ghosts, two friends, riding as passengers along the Division Street route. It is the first real time they have touched, and Jack feels the sensational panic of her palm against his own, and someone titters, someone says something indistinguishable, but the two ghosts ignore it, still pressing their fingers together. They sit like that all the way until Western Avenue when someone, from somewhere in the back of the bus, throws a soda pop can at the side of Jack's head and then calls them faggots, at which point they finally climb out.

At the bus stop on Western, the ghosts make their way off, Odile pausing with her silver paint pen to write *ALPHONSE F. WAS HERE* on the bus stop sign, before she turns and sees Jack holding his head. There is a jagged scratch along his temple where the pop can hit, and it is a little bloody, sticking to the edges of the white sheet.

"Wow. That doesn't look so good," she says.

"It really hurts. I think I've got minor brain damage already."

"How far do you live from here?" she asks.

"I dunno. It's pretty far."

"We can go to my place then," she whispers, and gently touches his forehead. And taking his arm in her own, she says, "Okay. Let's go," and off they stumble, dumping the sheets in a trash can.

IT'S NOT ROMANTIC.

Because his forehead is bleeding pretty bad and Odile insists on putting a Band-Aid on it. Off come their wet shoes at the door. They take their coats and hats and put them over the green sofa, and then Jack sits there and Odile walks into the bathroom and begins picking through the medicine cabinet and then she stands before him and gently places the plastic bandage over his cut.

"I'm so sorry," she says. "I didn't think people would throw stuff at us."

"Me neither."

"Do you want to lie down?"

"No, I'm good."

"Good."

She paces around a little and then asks, "How about a soda pop? Do you want a soda pop? You can drink some of my roommate's."

"I'm okay," he says. "I think I might go home, if that's all right." He stands and the small apartment goes a little blurry in the corners.

Odile takes his arm, steadying him. "Don't go. Wait a few minutes. Until you're sure you're okay."

"I'm okay. Really."

"No, now I feel bad. This was all my idea. And you were the one who got hurt."

"It's no big deal. I've been hit on my bike plenty of times. It's no worse than that."

"I always end up ruining everything. I swear. I can't help it."

Jack holds the sore spot on his temple and thinks about kissing her again. What would she say or do?

Before he can go through with the thought, she takes his hand and says, "If you don't want to talk to me again, I understand."

"I still want to talk to you. I just need to go home for a while."

"Okay."

And then he turns at the door and, without thinking, ignoring the throbbing of his head, he says, "You know I like you, right? That I'm interested in you? You know that, right?"

"What?" Her wide face goes flush, like a far-off stoplight.

"I mean, you know I like you, right? You're aware of that?"

"Please don't talk about it," Odile says, putting her hands up over her ears.

"Why not? I mean I do."

"Please, let's not talk about it. Things are so weird right now as it is. I'm leaving in a few weeks and there's Paul, and I dunno. Let's not discuss it."

"Okay, I just wanted to know if you were aware. Of the situation, I mean."

"Please," she says, unable to look at him, still covering her ears with her hands. "Let's just drop it."

"Okay."

And she does not look at him for a few moments, just stands, staring down at her stockinged feet.

"Are you sure your head's all right?" she asks, her eyes hidden by her dark brown bangs.

"I'm okay."

"Okay. Well. Then. I guess I'll see you later."

"Sure."

"Okay. Bye," she says, her voice, for the first time since he met her, sounding unsure of itself.

"Bye," he says, and then he tramples down the moldy carpeted stairs, partially wounded, out into the snow.

ON THAT FRIDAY AFTERNOON.

Unbelievably the bandage stays in place as Jack rides his bicycle to the restaurant on Grand Avenue to meet his stepfather for lunch. At Gene and Georgetti's it's all polished wood and red vinyl chairs, with cloth napkins folded in little red tents everywhere. It's a place Jack could never afford to go to on his own. His stepdad, David, is seated near the back, already helping himself to a glass of Canadian Club whiskey. It's a few minutes after twelve and seeing his stepfather drinking so early makes Jack a little apprehensive. David's face looks long and tired, the hair on top thinning, the eyebrows more gray than he remembered, the eyes themselves small and sedate.

"Hello, David."

His stepfather stands and wraps his narrow arms around him, kissing him on the forehead.

"There's my boy. There's my pal. What happened to your noggin there?"

"I got knocked off my bike again."

"Jackie, when are you gonna give up riding that thing and think about taking public transportation?"

Jack does not have an answer and so he shrugs, taking a seat at the table across from his stepdad.

"I have a little present for you," David says, reaching over to the chair beside him. "Close your eyes. No, don't close your eyes. Here, close your eyes and put out your hands."

And Jack obeys and feels the weight of something being placed before him. He opens his eyes and finds a brown paper

shopping bag, its handles looped over his open fingers.

"What's inside?" Jack asks, and begins to open it.

"Only the most important gift I've ever given anyone in my life."

Jack reaches inside and lifts out a smooth cardboard LP cover. It's Miles Davis, *Kind of Blue*. Jack smiles. He picks out another, Dizzy Gillespie. He picks out another, Lionel Hampton. And then another, a forty-five, the Flamingos, "Golden Teardrops."

"You used to play these for us when we went to bed."

"I know. I think it was the best thing I ever did as a temporary parent."

"I loved these records so much. I used to fall asleep to that one part on this Dizzy Gillespie record every night."

"I know it," his stepfather says excitedly. "I used to come in and look at you. Your mother hated that I played these for you. She thought it was too black. She thought it was going to turn you into a dope fiend or bank robber or something."

"I don't know what to say. These are really amazing."

"You don't have to say anything. Take them and be happy."

"I will," Jack says, inspecting each record cover, turning them over to look at the liner notes. He stops at a small forty-five that's slightly warped, the label itself faded and worn. "What's this one?"

"It's the Drifters. 'Save the Last Dance for Me.' December 1960. It's a masterpiece, Jackie. One of my favorites of all time. Do you remember it?"

Jack nods. "I think I do. Maybe not."

"You got to remember it, Jackie. It's probably one of the best songs ever recorded in America."

Jack nods.

"Do you know who wrote it?" his stepfather asks.

Jack shakes his head.

"Doc Pomus. He had a partner too, Mort Shuman. Two brilliant Jews. They wrote a ton of hits. 'This Magic Moment,' 'Little Sister,' 'Suspicion,' a couple of other tunes for Elvis. You remember those, don't you?"

Jack nods again.

"The thing most people don't know is, well, Doc Pomus, he had polio. When he was a kid. So he had to walk around with crutches all the time. Then he fell for this girl, this dancer, she was an actress on Broadway. They got married, and at the wedding, everyone, well, they're all taking turns dancing with the bride. Here's Doc, a big guy, but he's just sitting there, he can't even dance with his girl on their wedding day. So he writes this song to tell her, *You go and have fun, but remember who's taking you home.* Most people don't know Doc Pomus had polio. They probably just think It's this silly teenage song. But it's perfect, actually. It's this guy, this heartbroken guy, using this kind of silly medium, a pop song, and doing something transcendent with it. When you think about it that way, it's really a pretty important work of art. Don't you think?"

Jack nods and looks down at the records. He pushes his glasses up against his face and asks, "David?"

"Jack," his stepfather replies in the same worried tone, but smiling, and then taking a long sip of whiskey.

"What's going on here?"

"Can't a stepfather give a gift to his stepson every so often?"

"He can." Jack picks at the fork and knife before him. "Is that what's happening here?"

His stepdad smiles, the smile then losing faith in itself, becoming a soft, flaccid frown, and then his dad nods, coughing into his cloth napkin, and says, "I'm having surgery. In a week or so."

"Surgery? What kind of surgery?"

"It's a little embarrassing."

"It is?"

"Apparently I have a hernia. Right there above my testicles. It happened when Magdalena asked me to move a box. I bent over, and then, I dunno. I tore something. And so the doctors decided I need to take it out. Pretty minor stuff. Nothing to worry about."

"Are you being honest with me? Or is it something bad? I mean, is it dangerous?"

"No, no," his stepfather says. "There's nothing to worry about."

"But what about the records? Why are you giving them to me if it isn't serious or anything?"

"The records are because I love you and if anything happens, God forbid, I'd hate them to end up with someone who doesn't appreciate them."

"But what about Magdalena?"

"Oh. Magdalena," his stepfather says, nodding. He takes another sip of his whiskey and sighs. "Well, the thing of it is, well ... Her and I aren't on the best of terms right now."

"What's that mean?"

"Well, Jackie, she left. About two or three months ago."

"When? Before Christmas?"

"Right after. I thought if we could make it through the holidays ... We were even going to couples counseling with a friend of mine. A marriage counselor. But it didn't take. I'm getting to be as bad as your mother. Two marriages, both down the drain. The only good thing to come out of either of them is my relationship with you and your sister. And your sister ... well, she's a little too much like your mother. She's got a list for everything. God forbid you ever try to get her on the phone. I'm saying too much. These things aren't for your

ears." He takes another drink. "So, the records are yours. The only thing you need to worry about is taking good care of them. There's a few of them really worth something."

"Okay, I will."

"How's your lovely wife? I missed you both on New Year's. I haven't seen her in some time."

And here Jack, against his better judgment, against his best sense of what's normal or right, decides to lie to his stepfather. "Elise. She's good. Everything's been pretty good."

"Work's okay?"

"Work's all right. The same thing, different days."

"You sound just like me," he smiles. "Listen, I'm going to give you some advice, not because I think you need it, but because I feel like I've earned it. The right, I mean. To give advice. Here it is: don't hold onto things. It's a problem the men in my family have. It's taken me a long time to figure this out. Me, my father, my grandfather, we collect things. We collect miseries. It's what we do. But sometimes the best thing to do is to just let things go. To let them pass."

Jack nods again, unsure of what his stepfather wants him to say, and so he says nothing, until, trying to change the subject, he asks, "Is Magdalena going to take you to the hospital? Do you want me to?"

"What? On the back of your bicycle?"

"No, I have a car."

"The hatchback? From college?"

"It's buried in the snow right now. But I could take you."

"No, Magdalena said she would. We're still being cordial. Unlike your mother and me, we're at least still trying to be polite. I should only be in there for a day or so. But if you want to come by and visit, I can get you the information."

"Okay. No, I mean, I definitely will."

Jack's stepfather nods, and then slowly he reaches across the table and puts a large hairy hand to the side of Jack's face. "You. The world's your oyster, kid. Go out and do something big. Make some bold plans while you can. Before your body starts giving out on you. I'm sixty-three but I feel like eighty-three." His stepfather laughs, dabbing at his chin with the red cloth napkin. "God, I sound like a motivational tape. Pay no mind to what this feeble old man has to say. Just ignore me, dear. But not before you pass the bread," and Jack nods, reaching over to put the basket of rolls in his stepfather's hands. And it's then that he notices David's hands are shaking, the knuckles, the fingers, the hair on the back of his hands, even the palms, all of it trembling.

TAPES.

On his way to work that Friday night, Jack rides along Milwaukee Avenue, past the bombed-out-looking apartments that have somehow managed to avoid gentrification. At the stoplight on Grand Avenue, right before Milwaukee tapers off into a grimy dead-end alley, there is a bus stop shielded in plastic, with hummocks of snow piled up around it. A woman, adrift in a massive gray vinyl coat, is holding her child's hand, her child, a boy, in a blue winter cap and red mittens. The boy is playing a red plastic kazoo, humming some song that is making both of them smile, and Jack, pausing there at the light, still thinking of his stepdad, takes out his silver tape player and records ten seconds of that.

AND THEN.

Before Jack's shift starts that evening, Gomez, the night manager, calls him into his office, and while Jack tries to come up with an explanation for why he's such a lousy worker, why he has been tracing the shape of his hand over and over again, Gomez, scratching his sweaty mustache, asks him, "What are your plans for the future, Jack?"

"My what?"

"Plans. For the future."

"I don't know. I really don't have any."

"Well," Gomez says, taking a seat in his overburdened chair, "it looks like you're the sales leader in the office for this month. We just got the sales reports this afternoon and I wanted to congratulate you."

"Me?" Jack says, pushing his wrecked glasses up the bridge of his nose. "Are you sure?"

"I didn't believe it at first either. But the figures are all there." He motions to a stack of smudgy papers. "It turns out you're exceptional at sales."

"But I don't do anything. I just read the script."

"Well, everybody, all the day managers and myself, we're all pretty impressed. There's even talk of moving you up to assistant night manager."

"What?"

"I know. It's pretty exciting."

Jack nods, though what he feels then is not excitement at all.

"If you've got any interest—in moving up, I mean—you should let me know. There's salary and benefits and

everything. We could really use someone like you."

Jack does not know what to say to this, only scratches the back of his left hand.

"Well, I'll let you get back to it," Gomez announces. "Let me know if you come to a decision, all right?"

Jack nods, almost begins to speak, and stops himself. He turns and walks out of the dank little office, then returns to his overly lit cubicle.

Odile peeks from beneath her bangs, her face appearing from beyond the straight angle of the cubicle wall.

"What was all that about?" she asks, with a high degree of suspicion. "Are you in trouble?"

"No. He said he liked my work. He said I'm the sales leader in the office for the month."

"What? You are?"

"I guess so."

"But you don't ever do anything."

"I know. That's what's so weird about it. I don't even try. But somehow I'm good at this."

"Yeah, that's pretty weird."

"Maybe this is what I'm meant to do. Maybe I have this gift for convincing people to buy really terrible music. There's all the other things I've tried that didn't actually work out, and here, here I don't even try and they tell me I'm good at it. I mean, they want to make me assistant manager and everything. It's really kind of interesting."

"So what did you tell him?"

"What?"

"What did you tell him?"

"I told him I'd think about it. I don't think this place is going to be my future but, I mean, if it's more money ... and benefits ..."

"Yeah, sure," she says. "Well, that makes sense."

"It does, but not really."

"Why not?"

"All it means is that I'm good at a job I really don't care about. And that I'd be willing to work somewhere I don't even like very much, just because they tell me I'm good at it."

Odile nods, scratching at her arm. "I guess. So how long did they give you to think about it?"

"I don't know. I didn't even ask."

A phone rings somewhere and Odile frowns and then disappears behind her cubicle wall for a few seconds. When she returns, she leans back in the office chair and fixes her gaze on him.

"I made you something," she says.

"You did?"

"Here," she says, and extends her small white hand. In the center of her palm is a small black button with a pin attached to the back, encircling the letter F.

"F?"

"For Alphonse F."

"You made this?"

"I did. Now we each have one," she says, pointing to a similar button pinned to her sweater.

"Thanks."

"No problem."

And he grins, gawking down at it, pinned to his shirt.

"So tomorrow's Saturday," she says.

"Yep."

"And I was thinking of going to this art gallery. To see this show. There's this girl I went to art school with. She has a show. I actually kind of hate her. But I still want to go. Do you maybe want to come with?"

"What about your imaginary boyfriend, what's-his-name?"

"I don't have an imaginary boyfriend."

"You know who I'm talking about. Your lover."

"Who, Paul? We don't really see each other on the weekends."

"Wow. That sounds romantic," he says, teasing.

"It is. It's actually kind of perfect. We never get bored of each other."

"Right. I could see how that would help. Never seeing each other."

Odile sighs, her hot breath blowing up the ends of her bangs. "Do you want to go or not?" she asks.

"Sure. I'll go."

"You will?"

"Sure, why not?" And like that a plan is set.

ON THE WAY TO THE ART SHOW.

Odile announces that what they're really missing is a manifesto.

"A what?" he asks, pedaling briskly to try to keep up.

Odile slows down, riding beside him. "A manifesto. Like the Surrealists. Or the Situationists. Or the Theatre of the Absurd, you know?"

"Not really."

"We need something to hand to people and say, *This is what we stand for.*"

"I don't stand for anything."

"I know. Me neither. But that's why we should do it."

And they ride further south along Milwaukee Avenue, passing the expressway, the bread factory, the bombed-out-looking apartment buildings.

"The other day I found out my stepdad's getting surgery," Jack shouts.

"What?"

"My stepdad. I had lunch with him. Yesterday. He said he's getting surgery and then he gave me all of his favorite records."

"Wow. That's really nice of him."

"It is. But it's also kind of scary."

"Why?"

"Because it makes me worried that he's going to die. And I don't know. I'm almost twenty-six, and I think what a disappointment I must be to him. To my parents. I mean, what do I have going for me? Nothing. I think he was already finishing his degree and probably opening his own practice

at my age and everything. And I don't have anything to show for myself. Except the fact that I'm already divorced. I don't know. I feel bad. I feel like I need to do something important instead of screwing around."

"You're not screwing around."

"I'm not?"

"No. You just haven't figured it out yet," she says. "I think it takes a long time."

"Really?"

"Really. I'm still trying to figure things out too. All I know is a couple of very unimportant things."

"Me too," he says, but not loud enough for her to hear. "What I care about no one else seems to even notice."

"Like what?"

And he thinks about telling her all about the tapes, the recordings he has made, the city of sound he has been trying to finish. "I really don't know," he says.

"I think this should all be part of our secret society. The art movement."

"What should?"

"Like being in favor of unimportant things. Insignificant stuff. Things that get ignored. Things nobody else cares about. Like Post-it notes. Or push-pins. Or paperclips. I mean, have you ever really looked at a paperclip? It's pretty amazing. I was looking at one the other day and they still look like they're from the future or something. I think we should be for the small stuff, the stuff no one even thinks of as art. Like fire hydrants. Or gym shoes. Stuff like that. And we should be against anything popular, anything that's made for mass consumption, like movies, or TV, or songs on the radio. We should only be interested in the things that aren't really interesting. Broken things. Incomplete things. Things that don't last. Like lame fireworks. Or snow drifts. Anything

insubstantial. Anything that isn't art. Personally, I'm against anything by Jim Dine. Or Roy Lichtenstein. Or Andy Warhol. The only good thing he ever did was help get the Velvet Underground started. But I'm against all his other stuff. Anything that references pop culture. Because the only really interesting things, the only really lovely things, are things that don't last, things that nobody else knows about."

"You should write all this down," Jack says, "it could be your manifesto," and Odile nods and then, up ahead, along an unmarked side street, is the art gallery.

Before they are off their bikes, Odile has taken out her silver paint pen and has written, *ALPHONSE F. DESPISES THIS PLACE,* with a small arrow pointing right toward the gallery. And then, after some shuffling of their feet, the two of them go in.

ONCE INSIDE.

There are some young, trendy, glamorous-looking people, some people with obvious trust funds, some people who seem bored to tears, some people who look like the only reason they came was to score cheap cocaine. Everybody is wearing a fashionable scarf, men and women alike. Everybody's dressed well and so both Odile and Jack feel more than a little out of place in their salt-speckled winter coats, Odile in a dress she stitched together from remnants, Jack in a grimy T-shirt. On the walls are some pretty decent paintings, except that in each there's some obvious over-the-top cultural reference: in one of the paintings, Winnie the Pooh is mainlining what is probably supposed to be heroin. In another, Mickey Mouse is preparing to hang himself. Odile and Jack stand before the paintings and roll their eyes at each other, moving from one image to the other, until Odile whispers, "These are so boring."

"They're terrible. They look like something a junior high school student might do."

And Odile nods and says, "We should at least get some free booze," and Jack nods and they head over to the small table where there is wine and beer and cheese and there, dressed in a white turtleneck and gray sport coat, is someone Odile would rather not see. She turns quickly, her face going red, and grabs ahold of Jack's hand.

"What? What is it?" he asks, but she just shakes her head, keeping her back to the person in gray. Jack peers over and sees a man whose round head is slightly balding. He has a white Van Dyke beard and modern gray glasses and is

gesturing emphatically with a wine glass in one hand and, in the other, a full plate of cheese.

"Who is it?" Jack asks, and Odile leans in close to him and says: "It's this professor. He's pretty much the reason I quit art school," and Jack looks over, trying to see what it might be in this man's manner that is so intimidating. But all he sees is the man talking, taking several cautious bites of cheese.

"Let's get out of here," Odile whispers, but Jack says no, and walks over, picking up another bottle of beer. He leans in, listening to the professor's conversation. Apparently he's speaking with a stranger, or maybe some former pupil, Jack can't really tell.

"I think the greatest asset of postmodernism is its irony and general disdain for the simpler, more ... how should I say it? ... maudlin emotions. We need great artists who will posit the big questions without resorting to whimsy. That's precisely what I love about Mika's work here."

Jack smiles and then walks back over to where Odile is standing. "He sounds like a douchebag."

"He is. You should have heard what he had to say about my stuff. He pretty much represents everything I hate about art."

"We should follow him," Jack suggests.

"What? Why?"

"I dunno. We should. We should do something to him. Scare him or something."

"Like what?"

"I don't know," Jack says, glancing over at the professor's thin frame. "Something."

And then, without noticing them, the tall professor walks past the two of them, stopping before an oil canvas of Big Bird holding a machine gun, the professor keeping his hand to his bearded chin long enough to declare, "This is what we need

more of, art that challenges assumptions," before turning to join a collection of other bespectacled art enthusiasts.

"Let's go," Odile says again, and Jack nods and they hurry back outside, laughing for no real reason, and head over to unlock their bicycles from the parking meters. It is then that Professor Wills steps out, pulling his overcoat across his narrow shoulders, lowering his bearded chin into the recesses of the folds of his turtleneck. Odile and Jack watch him go, watch him cross the street to a boxy-looking teal Subaru; they see the flecked green-blue color, see the dent on the driver's side, see the model and license plate, and then watch the art professor pull away, suddenly aware that certain machinations, certain elaborate revenge strategies, are already falling into place.

Jack looks at Odile and smiles googly-eyed, and asks, "Was that him?" and she nods, and he says, "We should do something to him. Or to his car. Or his house. Something. Do you know where he lives?" and Odile shrugs again, the plot starting to take shape, before she pulls her pink mitten back on and says, "It wouldn't be too hard to find out," and then they ride back down Milwaukee Avenue in near silence.

At the corner of Augusta Avenue, they part ways quietly, neither putting a word to the distracted notions, the complicated thoughts, the sense that the brilliant, refracted lights of the city are all the feelings they are now feeling.

A MANIFESTO.

Then on Sunday morning who should telephone but Odile? And he climbs out of bed and answers the phone and is surprised by how her voice sounds on the line, much huskier and somehow older, and she says she's planning a new project and does he want to come help? And he says okay, and wonders what would happen if he ever said no, which he knows by now he won't. And they meet by the corner, and ride their bicycles to the corporate copy shop where Odile's roommate Isobel works, and Isobel has blond hair and is pretty good-looking but more in a self-involved kind of way, and Isobel gives them the code to the self-service machines, and together Odile and Jack make one hundred pink posters announcing:

YOU ARE NOT DOING
SO GOOD AT BEING
HAPPY.

STOP BELIEVING POP
CULTURE WILL SAVE YOU.

UNIMPORTANT THINGS
ARE THE MOST
IMPORTANT.

ANYTHING THAT LASTS
LONGER THAN TEN SECONDS
IS A LIE.

WE ARE LOOKING OUT
FOR YOU.

ALPHONSE F.

Together, once again on their bicycles, they put on their ski masks, Odile in the black one, Jack in the red, and they post these pink sheets of cardstock everywhere, gluing them to walls, to signposts, to metal trash cans, with a mixture of wheatpaste and rubber cement. They put these posters up on the sides of buildings and over other posters announcing upcoming rock shows, and once they have glued all them up, Odile takes off her black mask and places her white winter hat back onto her head. Jack does the same and then looks up and sees her staring at him for a moment, until she asks, "Do you want to see my favorite place in the city? It's only a few blocks from here," and Jack says, "Okay. Why not?" and Odile laughs viciously and pedals off as quick as she can. And there is something in that laugh, some intimation, some kind of question, and Jack, riding his bicycle, sliding in the wet snow, follows it, and silently tries to answer it, and two blocks away both of their faces are already bright red.

BUT IT'S MORE LIKE FIFTEEN BLOCKS.

Jack follows her green bicycle on his blue ten-speed and they end up at the Blommer chocolate factory farther south on Milwaukee Avenue. It's a triangular-shaped building with faded red and gray bricks and, other than its intoxicating, rich smell, looks rather unassuming.

"What is this place?"

"Can you smell it?" she asks, and he nods and it smells exactly like the entire city block, the whole metropolis, is made of milk chocolate.

"It's pretty incredible," he says.

"It's just like what we were talking about. Because it's like only a smell. It's like probably something most people don't even notice. But it's one of my favorite things. Because it's a secret. I mean, you have to kind of know about it to come over here."

"I get it."

Odile nods, tilting her nose up to breathe in the chocolate scent. "I really love it. If I ever move to New York, this'll be the only thing I miss."

"Really?"

"I mean, I'm sure I'd miss more than that. But not much."

Jack pulls down his winter cap over his ears, wanting to say something to rebut her, but does not think of anything.

"So do you want to see something else?" she asks. "It's pretty cool. I found it a few weeks ago when I was riding by myself."

"Okay."

"Are you afraid of heights at all?"

"Not really. A little."

"Okay. Let's go," she says, and begins pedaling off again. And once more, Jack rides behind her, the pitch of her shoulders, the wuthering hair dancing backward in a brown flutter, meeting his gaze. And now it's starting to get dark, and the lonesome stillness of the end of the weekend, of the final hours of the evening, sets in. And all this time, Jack's thinking this: *What would it take for us to kiss*? But again, he watches her go.

OFF THEY GO TO AN ABANDONED BUILDING.

"Hello!" Odile shouts, and the echo sounds like some future song, her voice ricocheting softly off the empty walls, and Jack is looking up at the abandoned building, and Odile is smiling wide, and he asks, "What is it?" and she says, "It's a secret," and Jack looks at her with an expression that he imagines must reveal his doubt, and she is tugging his sleeve again, and they are ducking past a fence and sign that says, *No Trespassing,* and he leaves his bicycle against an unadorned beam and there is the sound of dripping water everywhere and he follows her through a square hole in the building and Jack can see her shadow and the back of her head and her hair beneath her hat and she is turning to smile at him and he can see those crazy bangs again and then they are climbing a flight of stairs, and then another, and then some more, and they are eight stories up and now there is the city, and it is submerged in snow, though it's still so big, rising before him everywhere, because the windows in the building, the sashes themselves, have already been taken out, and the wind is pretty strong and Odile is standing near one of the open spots, pointing, and he looks down and he sees how far the drop is and feels his knees go limp and she is laughing, standing beside him, and it's not the city as he always imagines it, it's something altogether different because of the sound of the girl's laughter and the fact that it's so big, so vast and unconquerable, and now it's buried in snow, a ghost city, a blank city, the idea of a city, a city of every conceivable possibility, and then she is saying something he can't hear because of the wind, and he

says, "What?" pointing to his ear, and she says it again: "It's getting torn down next week. I rode by this place and there was this demolition crew and they were taking measurements and everything. I talked to them and they said sometime next week. Isn't that weird to think about?"

Jack backs away from the window. "Yeah, that's kind of weird."

"Are you scared?" she asks, laughing.

"No. A little." And then, "I guess."

"I used to be really scared of heights. When I was kid," Odile admits.

"You were?"

"Just a little. Now it really doesn't bother me."

Jack looks down and feels his legs are still wobbly. "I never liked heights."

"What else are you afraid of?" she asks.

"Just heights, I guess."

"When I was a kid, I used to be afraid of everything. Now the only thing I'm scared of is if people like me or not."

"Yeah," he says.

"It's weird. Sometimes I think there's something seriously wrong with my brain. I want everyone to like me, even if I don't like them. Like my roommate and people at school. Even my family. I have this weird thing about being liked by everyone. I don't want anyone to think I'm a bad person, or mean. So I do things I end up regretting. Like I loaned this money to my roommate and I know she's never going to pay me back. I don't even care about the money. It's the fact that I gave it to her, you know? And I don't know why I did it. I just wish I didn't care if people liked me or not."

And Jack nods, smiling, the two of them still leaning against the open window.

"When I was eighteen or nineteen," she continues, "I

had this boyfriend in art school, and he was my first serious boyfriend ever. Brandon. He was so nice and I ended up cheating on him. It was weird. I didn't want to, but I did. The first chance I got, I cheated on him. I don't know why. I mean, it was like, I met somebody, this guy at this party, and he wasn't anything special, but he seemed nice, and immediately I felt like I had to get him to like me. So I cheated on this really nice guy for no reason. I don't know. I think it's a pretty serious character flaw, you know? To do things like that. I think it's one of the reasons I want to leave. Because I'm tired of trying to get people to like me."

And Jack nods again.

"I feel like I'm at the point where I need to decide who I'm going to be," Odile says. "I don't feel good about anything I've done so far. I think that's why I want to go to New York. Because it's easier than having to figure all these things out here."

And she looks at him and smiles and says, "Okay. Wow. I think I'm going to shut up now."

And he nods and they are walking down the flights of stairs and she is a few steps below him and he can see over the top of her white hat and she is still moving and then she has stopped to stare at a pair of icicles that have formed and they are standing in the stairwell beside each other and then he just says it.

"I did something pretty dumb when I was eighteen."

And she is turning, looking up at him, and she asks, "Yeah?" and he says: "Yeah. I was away at school, on the East Coast, in Massachusetts. It was only a few days since the semester had started but it was the first time in my life I was away from home, from my parents and my sister and people I knew, and all the trees looked different, you know, and I knew they were the same but they still looked different because I

didn't recognize anything, I kept getting lost everywhere. I mean, every time I left my room and went outside, I'd get lost, and everyone seemed so happy, they were all happy to be at college, because this was real life to them, and it was finally starting, you know, but it didn't feel like it was starting for me, because even after a week I was having a hard time keeping up with the classes. My roommate, he was this guy, and he knew a lot of people, so there were always these people in my room, coming over to visit, people I had never met before, guys and girls, and I never had any time alone, I never had any time to be alone in the room, you know, and so it kind of got to me, and I'd just go out walking so I could be alone. Then I'd start to feel better and I'd think I was going to make it, and I'd try to go to my classes, but I didn't know any of the people there or my teachers and I started going out less and less, and because I had the top bunk I would just lay there while people came and hung out in our room and partied and did coke, and then one night I was lying there and my roommate came in, and he had this girl with him, and he had done that before, have a girl with me there, and they were like going at it, and I was lying above them and I could hear them kissing and the girl even asked, *What about your roommate?* and my roommate said, *He's not here, he must be gone for the night,* and then they went back to kissing, and I don't think they even knew I was there, I think maybe they were drunk, but that's what made me so mad, you know, they didn't even know I was there, and so then I climbed down and the girl said something and I went to the bathroom, one of those big common ones, and someone had left their shaving kit there, and I found a plastic razor and tried to cut my wrist, but all I ended up doing was getting a razor burn because it was a safety razor and I couldn't figure out how to get the blade out, and so then I decided I would try to freeze to death and I walked outside in

my pajamas and it was November but it had snowed already and there was snow and leaves everywhere and I thought this is as good as it's going to get for me and then I laid down in the snow and it was already five or six in the morning and then a security guard came and tried to get me to stand up and I told him I didn't want to, that I was trying to kill myself, so he had to carry me into the back of his patrol car and bring me to the hospital and then the school called my parents and I've been dealing with it ever since. I mean, this was all ... I dropped out of that school and then went to art school after that. Then things got better for me. But. What I mean is, I'm not a bad person. I just get depressed. We talked about it before but now I'm telling you. I do get depressed, and I don't know why, but it's only for a couple days at a time and then after that I'm usually pretty good, pretty great actually. It's weird. I just can't be around people all the time because It makes me sad to be around them sometimes. I think maybe that's why my wife left. If that makes any sense. I can tell by the way you're looking at me that it doesn't. But it does. It's an actual medical condition. I'm on medication for it. Are you looking at me funny or are you just looking at me?" he asks.

And there she reaches up and puts the rounded shape of her pink mitten to his lip. And then they almost kiss but then they don't. They can't. Too much has been said maybe. He doesn't really know.

"Let's go to my place," she says, and he is blushing and nodding his head and his forehead has broken out with sweat and somehow they are once again riding down the street, the bicycle wheels spinning beneath them.

ANOTHER ACT OF ART TERRORISM.

Together they hurry up the front stairs of Odile's apartment building, both of them dragging their bicycles up the steps, and they are almost silent, as if they know something interesting is about to happen, and the key is in the lock, and the door is opened, and the two of them step inside, and Isobel, Odile's roommate, is sitting on the sofa watching TV, and she makes a brief declaration: "The president was acquitted," and both Odile and Jack pause there, staring at the screen, and Odile asks, "What?" and Isobel says, "The president was acquitted for getting a blowjob and lying about it. He's not impeached anymore," and Odile asks, "When?" and Isobel says, "I think on Friday maybe," and Odile says, "Really?" and Isobel says, "Yeah, I just watched an episode of 20/20," and Odile says, "Wow. Well, it serves those assholes right. We should do something to commemorate the occasion," and Isobel tilts her head in such a way that defines the narrowness of her face, something a model would know how to do, Jack thinks, and then she says, "Like what?" and Odile says, "I don't know. Let's just go do something," and Isobel says, "Thanks but no thanks," and Odile asks, "What about you?" and Jack shrugs, but Odile grabs his hand anyway and they rush back down the stairs, out into the street. And it is a quiet Sunday night and the city feels empty but this does not stop Odile.

Hand in hand, they run to the corner, and then another block, right out in the middle of Division Street, and Odile runs up to a car stopped at the stoplight and begins pounding on the window and Jack stands there wondering what he

should do, and Odile is yelling happily at the people sitting in their cars, waiting for the light to turn green, and then she is unbuttoning her coat, and shouting, "Whoo-hoo, woo-hoo, U.S.A., U.S.A.!" and she begins flashing the traffic as it blurs past, holding her shirt over her pink bra with both hands, and Jack cannot help but gawk, and cars start to honk their horns, and some of them even slow down, and Jack tries to get her to pull her shirt back down, but she isn't interested. She only laughs and runs off, half a block down to another stoplight, and here, tapping on car windows, is where she actually unbuttons her jeans and puts her rear on someone's window, and cars are beeping, some of them annoyed, some in applause, and Jack can see the daintily stitched hem of the girl's pink panties riding up above the unbuttoned waist of her pants, and then he runs over and pulls her out of the street, and she laughs and pushes his arm away, and there is something like a small, wild animal in her, and she tries to untuck Jack's shirt and get his pants down, and she says, "Don't be such a tightass," and he says, "I'm not a tightass, I just don't know what you're doing," and she says, "We're celebrating the right to be stupid, which is probably the most important right we have in this country. We're staging an impromptu performance piece," and she lifts up her shirt again, flashing her pink bra at a passing car, and Jack grabs her wrist and says, "Stop," and she says, "No," and he says, "Stop it," and he has his hand on her jacket and someone is honking and she flashes them with a hostile, feral grin, and then runs over and pushes her bra against the passenger-side window of a dirty-looking Buick, and Jack grabs her by the shoulder and says, "Odile, just stop," and the moment she turns is when he decides to finally kiss her, and it is soft and hard at exactly the same time, and she lets herself be kissed, but does not kiss back at first, not until she bites down on his lip a little, and then he has her

hand in his hand and is marching her off somewhere and she says, "Where are we going?"

"I live a few blocks from here," and Odile says, "What about our bikes?" and he says, "We can get them on the way," and she nods and says okay. And then they wander off in silence, both of them slightly starry-eyed.

BACK TO HIS APARTMENT.

But it does not happen the way it does in the movies, maybe because it is winter and they have to take off their hats and coats. Once their shoes and jackets are off, he sits there as Odile looks around the apartment, wide-eyed, taking in all the shoe boxes arranged in tall angular stacks everywhere, and she says, "This is pretty weird. What are all the shoe boxes for?" and Jack is looking at her, at her dark hair, at her soft mouth, at her long neck, and how she is walking around inspecting everything in her black-stockinged feet, and she points to a box and asks, "What's this one?" and then another, "And this one?" and Jack stands too, leaning beside her, reading the small labels he has made. "Birds," he says, or, "Airplanes," and she is squinting, looking at them all, and then he does not know why but he says, "I'd like to show you something. Sometime. Whenever."

"Really? What?"

"It's supposed to be a secret, and ... well, it's not finished yet but I'd like to show it to somebody. If you want to, I mean."

"Okay."

"It's not entirely ready but ..."

"You're so gay."

"Sorry. I'm just nervous. I've never showed it to anybody."

"When you talk like that, it makes you sound like a virgin."

"I'm not," he says. And then once again, "I'm not."

"Whatever. Are you going to show it to me or what?"

Jack smiles and asks Odile to please sit on the sofa. She folds her legs underneath her and does so.

"Okay, I'm almost ready. Like I said, it's not really finished yet but ... Okay, this is it. Are you ready?"

Odile blinks. "I guess so."

Jack gathers his tape recorders, four of them altogether. "Okay, it's probably better if you close your eyes."

Odile smiles and then slowly closes her eyes. She tilts her chin up as she does this.

"Okay. Imagine you are stepping off a bus."

Jack hits play on the first tape recorder and the noisy exhaust of a bus rises in the air.

"And as you're walking, you can hear the birds chirping and feel the sun shining."

And here he hits play on the second tape recorder, the sound of a string of sparrows singing on a low telephone wire.

"Up ahead, there's a gigantic silver fountain, with statues of all kinds of fantastic mythical creatures on it. And a skyscraper in the shape of a castle is being built beside it."

And here Jack hits play on a tape and the sound of a public fountain quickly rushes to life. He then hits fast forward, and then play again, and the rattletrap of construction shortly begins.

"To your left is the city zoo. What kind of animals would you like to visit there?"

"I dunno. The seals?"

"Anything but the seals."

"Okay, the lion."

"How about the tiger?"

"Okay. The tiger," she says with a smile.

"The tiger. Okay," he says, searching through his shoe boxes of sounds. He finds the one he is looking for, slips it inside the fourth tape recorder, and the noisy roar of a tiger rings out. "As you keep walking, you find yourself in the middle of a wonderful atrium. And there are some bumblebees darting about."

Play and rewind.

"And there is also a lovely breeze blowing through the giant flowers."

Fast forward, play, rewind, play.

"Wow. This is pretty amazing," she says.

And Jack smiles, looking at her with her eyes shut, the shape of her lips, her teeth parted in a half-cocked grimace.

"Okay, well, that's it," he says, touching Odile's hand. She immediately opens her eyes. She looks up at Jack, raising her eyebrows. Neither of them seem to know what to say or do next.

"That was ... I don't even know what to say. Wow. It was really amazing. Really."

"Thanks. I've been working on it for a while. Four years, actually. I still have some other stuff to record, but, well, you get the idea."

Odile and Jack stare at each other for another long moment.

And there are their eyes, their noses, their mouths, all of them only inches apart.

And then they begin kissing again. It's good, a very soft, dramatic kiss, their mouths forcing themselves together. And then their hands start to go wild. And then they fall back onto the sofa, Odile folding her arm around Jack's neck, pulling him close. And he is pressing his body against hers. And his hand goes up beneath her sweater. And they both begin to undress each other. And then she says, "Once I fall for someone," but does not finish her sentence. And they start to kiss again and he is startled by how soft her skin is, the skin on her face, her stomach, her neck. And her legs are around his waist. And they are kissing hard. And he makes a soft noise and she says, "What's wrong?" and he says, "I have a bad tooth." And she says, "Sorry," and they start kissing again, this time

more softly. And then she is unbuckling his pants. And he is pulling off her blue jeans and laughing as the leg gets stuck on her left foot. And then he has his hand between her legs, and he can feel the soft fabric of her pink underwear there. And then he has his hand under the hem of the underwear and his finger is inside, up inside. And he's doing what he thinks he's supposed to, what he wants to do, what he hopes she will like. And it's going pretty great. And her mouth is beside his ear and he can almost hear her breathing but not quite. And their foreheads are pressed together, eyes closed, the heat unmistakable. It's the nicest thing in the world, having his forehead pressed up against someone else's like that. And then he is reaching over to get her soft pink underwear down and she is making a surprised expression with her eyes and then she is sitting up, saying: "Hold on."

"Sorry," and it's like he's out of breath and so he sits up too.

And she brushes her bangs with her fingers and sits up straight and says, "Okay. Wow. Just give me a second."

"Okay," he says. "Are you okay?"

And then she nods and says, "Okay," as if she has made an important decision about something. "Do you have any protection?"

"What?"

"A condom?"

"I think so."

"Okay," she says.

And he hurries off to the bedroom, and then hurries back, and lies beside her. And after he comes back, Odile pulls a crocheted orange afghan over them, although he can still see her bare shoulders. And Jack is on top and it's all elbows and knees at first. It's pretty awkward going. "I don't think I'm wet yet," she says, and he nods, feeling embarrassed for some

reason, and she says, "Okay, just slow down," and she takes his hand and places it between her thighs, and she begins rocking back and forth, and a few moments later, he does it, putting himself between her legs, and he tries to touch her small breasts but she says, "Don't touch my tits. I hate them," and he nods and holds himself up on his elbows and she has her eyes closed and is wrapping her bare legs around his waist, although she still has her black socks on, which look pretty funny. There's something goofy and sexy about it all at the same time. And he comes before he would like, too soon, too soon, and they lie together like that for a while before she says, "Excuse me," and waddles off to the bathroom, knees pressed together, the bare crescents of the backs of her legs disappearing behind the closed door. And he thinks he has to say something great, something really nice, and he is standing beside the bathroom and hears the toilet flush, and then they pass each other, smiling, and Jack gets rid of the condom, dropping it in the toilet, and Odile is already getting dressed, and he looks up at her as he searches for his pants and says, "I really like you," and she says, "Thanks. I really like you too," and they begin kissing again. In bed, on the sofa, in front of the sink. They kiss everywhere, again and again, over the next few hours, so much so that it scares the cat.

ON THAT MONDAY AROUND NINE A.M.

Odile leaves and Jack, smiling dumbly at the front door, places his fingertip to the flesh-colored Band-Aid still on his head. Everything about the apartment feels exciting, new, different, even the way the light through the windows is working. He has got it bad for this girl. Oh man. And even though she is two years younger and a little crazy, she is so unafraid of everything. It practically kills him. And as he's dragging his bicycle down the steps and out into the snowy street on his way to work that afternoon, he sees that on a parking sign, right in front of his building, someone has written

HELLO JACK

with a bright silver paint marker, and later, riding to work, he spots another handwritten note on the side of mailbox:

HI JACK

Then another on the façade of an abandoned storefront on Milwaukee Avenue:

HELLO JACK

Everywhere she has left him these small notes and so begins the best four days of his life. It's the beginning of the third week in February and they end up spending almost every moment of it together. On Monday, after work, they return to

Jack's apartment and lie in bed, Odile's bicycle propped beside his, right near the front door. They begin to do things to each other like they are children and have just thought up the idea of fucking, as something to do for fun, as something to amuse themselves. Odile is quiet but then laughs suddenly, which Jack finds really, incredibly attractive. He's never been with a girl who's laughed like that in bed, which is great but also makes him a little self-conscious because once or twice he gets afraid she might be laughing at him, at what he's trying to do. And after it is over, and they are lying in bed, he decides to put on one of his stepfather's records. First he puts on some Miles Davis. Then Stan Getz. Then he puts on "The Umbrella Man" by Dizzy Gillespie, and he watches her face as he plays the song for her a second time. And then, on that Monday night, at about three in the morning, they go out to get contact lens cleaner so Odile can take her contacts out at his place, and then returning, they pull each other to the wood floor, kissing each other's faces, neck, hair, falling back into the bed, neither of them speaking. There is a sound Odile makes which is so soft, so faint, like breathing, but faster, and also sort of like a cat, that makes it seem like they can't get out of their clothes again quick enough. And they can't. And they work out their questions about the world and each other through these spastic, eager breaths.

ON TUESDAY THEY DO THIS.

Following the ideas described in Odile's small green notebook, they traverse the city doing random, interesting things.

1. Blot out a movie poster for some Brad Pitt film using her silver paint pen near the corner of North and Damen. What remains is a murky silver cloud over the actor's face and the partial title of his latest movie.

2. Go to Odile's roommate's copy shop and make a large white paper banner that says, *YOU WILL FORGET THIS BY TOMORROW—ALPHONSE F.,* which they hang at the bus stop on Division Street using silver duct tape.

3. Buy three yellow-and-green parakeets from the bird store on Chicago Avenue and turn them loose in front of the schoolyard on Wood Street, the birds becoming multicolored puffs of air disappearing above the ice-covered swings.

4. Draw a picture of two ghosts having intercourse on a stop sign near Ashland using Odile's silver paint pen, complete with ghost boobs and a ghost dick.

5. Stop by the emergency room at Cook County Hospital, where Odile chickens out, taking Jack's hand in her own, ditching the puppets they had spent ten minutes making in a trash receptacle outside.

6. Awkwardly kiss at the corner of Chicago Avenue.

7. Hurry inside the Museum of Contemporary Art and tape up a portrait Odile has done of the famous artist Alphonse F., right between a painting by Warhol and a photo of Cindy Sherman.

8. And then outside once again, Jack checks his calculator watch, and off they ride to work.

AFTER WORK ON TUESDAY NIGHT.

Odile says she has another plan of attack and Jack asks a plan of attack for what? but she only laughs and they ride the elevator down to the lobby and hurry outside to unlock their bicycles, and once they're unlocked, they ride off a few blocks to the Blue Line subway station on Monroe Street, and then, following Odile's lead, they drag both their bicycles down the icy steps. And as they're waiting for the next train north, Jack asks, "What's this about?" but Odile doesn't answer, not at first. Later, ten or so minutes on, as the gleam and hum of the subway train rocks the platform, Odile leans close and shouts in his ear, "Have you ever seen the movie *Breathless*?"

"What?" he shouts.

"Have you ever seen the movie *Breathless*?"

"No."

"What about *Gone with the Wind*?"

"No. Well, parts of it."

"Okay. What about *Jaws* then?"

"Yeah, I've seen *Jaws*. A bunch of times. Why?"

And she winks at him and smiles, and then the subway doors are parting open, and Odile and Jack are climbing inside, wheeling their bicycles onto the train. The doors close behind them as they stand in the aisle, supporting the weight of their bikes.

"Wait until I give you the signal," Odile says.

"Wait for the signal to do what?"

"We're going to act out a scene from *Jaws*."

"Why?"

"It's tonight's project."

"But it's a movie."

"So what?"

"So isn't that referencing pop culture? I thought you were against that."

"It is. But it's doing something interesting with it. It's temporary. So it's like a movie only the people on this train car ever get to see. So it's better than a movie. We're creating a moment that will never be repeated again."

"I guess," Jack says, still not convinced.

The train speeds past Washington and when a group of college students, eyes hazy from drinking, stumble on, Odile gives Jack a wink.

"Who am I supposed to be?" Jack whispers.

"I don't know. You can be the police chief. Or the shark."

And he nods in suspicious agreement.

Odile stands, straightens her green parka, and begins to cross up the aisle, pedaling her arms in a stunted butterfly stroke.

"Here I am, swimming," Odile announces. "I am going skinny-dipping now."

And she mimes undressing but does not bother to unzip her coat. People on the train look up, questioning, a little confused. Odile stops swimming and then screams, fighting against the imaginary water. "Something has my leg," she says in a monotone.

A homeless man across the aisle cracks open his bleary eyes, trying to puzzle out what he is seeing. Odile now stands near the silver handrail, tipping her chin up, looking very formal.

"I am the Mayor of Amity Island. What a wonderful summer we are having. I sure hope nothing will force us to close our beaches. What's this? A giant shark in our waters?"

And she nods at Jack.

Jack, for the life of him, has no idea why he's doing this. But he does it. He does it because of the way she is standing there, because of the small moles on her naked back, because of the way she looks at him.

He gets to his feet and pretends to be a shark, miming the great gray fin with his left hand.

"I am a shark," he mumbles. "And now I'm eating people."

"Another murder! We better call in a marine biologist. And an expert shark hunter." Here she extends her hand, shaking Jack's. "It looks like we caught the shark we were looking for," Odile explains.

"No," Jack says, pointing down at the snow-covered subway floor. "There's no body parts inside. This isn't the shark we want."

"We're going to need a bigger boat!" Odile shouts, out of turn, ending the scene.

She takes Jack's hand and bows and then, grabbing her bicycle, heads off at the next stop on Grand Avenue. Jack follows, and once they're at street level again, he looks at her and says, "What do you think those people on the train were thinking?"

"I don't know."

"I think I saw a couple people laughing. But I wasn't sure. They could have been frowning now that I think about it."

"It's okay. I'm used it. It's just like in art school. Everyone there hated what I was doing because it wasn't obvious or bleak, or because it didn't take itself so seriously."

"Yeah."

"One time that guy, that one professor, the one from the gallery opening, he looked at this painting I made, and it was of an apple with a mustache lifting weights, and he said, *You're not going to be successful doing this kind of thing,* and I almost spat in his face."

"It just sounds like he was maybe a bad teacher."

"But he was the chairperson. Of the whole department. That's pretty much when I decided I was done with art school. There was this idea that if something was good, everybody in the class had to like it. Like it was a popularity contest or something. Like it had to be tragic. I didn't want any part of it. And so I said forget it."

Odile steps forward and there, a few feet from the entrance down to the Blue Line station, she grabs her silver paint pen and writes

ALPHONSE F. WILL DESTROY YOU, PROFESOR WILLS

misspelling the man's title and then inserting a small *F* above her mistake. Jack nods and they stand together beneath the caustic streetlights, admiring her work.

In bed together, a half hour later, they do not undress. They fall onto the mattress and wrap themselves tightly beneath the cotton blankets and then slip off wordlessly to sleep, Odile's fingertips sticky with the remnants of silver paint from her marker. And in the morning, at the arm's-length of dawn, finding themselves still pressed together, they do it backward, his mouth to the back of her ear, staring at the small television on the nightstand, watching a rerun of *Andy Griffith*, which is actually a program for the masses, but no one complains.

ON WEDNESDAY AT ONE O'CLOCK P.M.

But then the phone rings and Jack is in bed, taking a nap, and Odile is in the shower and so Jack answers the telephone without looking at the caller ID and there is a strange beeping noise for a moment and a couple of clicks and then there is Elise's voice and he knows it is her voice but he cannot believe it.

"Hello?" she keeps saying, and Jack does not what to say, how to answer, and finally he gets the word out, "Hello?" and she says, "Jack?" the way she always used to, a little unsurprised, a little disappointed, and he says, "Hello. Who is it?" even though he already knows who it is, just so she might think he has already forgotten the sound of her voice, and she says his name again, exactly the same way, "Jack?" and he says her name too, "Elise?" sounding more interested than he would like, and she says, "I had to call you. I had a terrible dream about the cat. Is everything all right?" and Jack feels relieved and a little heartbroken at the same time, and he says, "What?" just to make sure he isn't dreaming this nonsense, and she says, "I had a bad dream about Tiny. I wanted to make sure he's okay," and Jack says, "He's fine. The two of us are great," and she asks, "Have you been giving him his stool softener?" and Jack reels at the thought: the what? But he says yes anyway and then, "We've decided to change our names. After you left. We've started new identities," and Elise, the girl he married when he was only twenty-four, fresh out of college, still in love with the possibility of being in love, does not laugh.

"What are you talking about?" she asks, and he says forget it. And then Elise says, "Well, that's it. I was just worried. Otherwise things have been okay. School is really good. It's hard, but the teachers here, the professors ... it's really pretty great," and Jack wonders, from her words, how they could have lasted so long, even made it a year, and he says, "That sounds good," and she says, "I should probably go. I was just going to leave you a message. This is probably costing me an arm and a leg," and he says, "Sure, I get it," and she asks, "Hey, isn't it the middle of the afternoon? What are you doing home from work?" and he says it's a holiday, and she says, "What?" and he says, "Never mind," and they begin to say goodbye when finally he figures out what he wants to say, and he mutters, "I just want you to know you don't have to worry about me."

And the phone clicks and buzzes and she says, "What?"

And he repeats it. "I just want you to know you don't have to worry about me. I'm getting along okay. Things are actually pretty great," and she sounds a little surprised and says, "Well, that's good. I'm glad to hear it," and then he says, "But you shouldn't just call here and ask about the cat," and she says, "What?" and he says, "You can't just call here and ask about the cat like everything's okay. Like this is all normal," and there is a pause where he can hear the distracting hum of the international telephone line and she says, "I should really probably get going," and he says, "I've been thinking a lot and it's not that anyone did anything wrong. We just didn't know what we wanted. We weren't the people we were supposed to be yet," and she laughs and says, "Have you been watching daytime talk shows?" and he says, "No." And then he says, "I just hope you're happy in your future life," and she says, "What?" and he says, "I want to wish you the best in your future life," and she does not laugh this time but asks, "Are

you sure you're okay?" and he can hear the faucet being turned off, the shower no longer running, and he says, "I'm doing great," and she says, "Okay, I really have to go," and they make their goodbyes, and after he has hung the phone up, he knows, somewhere deep inside, he will not be talking to Elise again.

Odile emerges from the bathroom, freshly scrubbed and dew-wet, and the heat from the bathroom has made all of the windows in the adjoining bedroom filmy with condensation. And she pauses and writes something on the closest window with the tip of her right finger:

I AM OKAY.
YOU'RE OKAY.

And then there is a general shuffling of limbs as the two of them fall back into bed. And later they lie on the couch watching French movies until it's time to go to work. And even there, separated by the silver-green glow of the fluorescent lights, the bombastic, unrepentant dullness of the instrumental office music, and the odd angles of the carpeted cubicles, it's clear that what's happening between them is that, actually, well, they're probably both falling in love.

AFTER WORK ON WEDNESDAY.

Odile says, "I have another idea. Let's make a dirty magazine." And they ride to her apartment and she grabs her old Polaroid camera and Jack asks, "What's that for?" and she winks at him and off they go on another odyssey, this time Odile taking a snapshot of Jack's ear as they wait at a red stoplight.

Jack asks, "What's this about?" and at the corner of Augusta, she unzips her jacket and lifts her blouse up and points the camera at her chest, and what develops is a close-up of her nubbly black brassiere, and she shoves that picture into her pocket with the others, and then two blocks after that, she lifts her dress and takes a picture of her upper thighs, and there is the filmy white, triangular composition of her underwear, and then she hands him the camera and says, "Now, your turn," and Jack asks, "What am I supposed to do?" and she says, "Everybody's forgotten how to be shocked by the weirdness of the human body," and Jack says, "What are you talking about?" and she says, "Just take a picture," and he says, "Fine," and opens his mouth and pushes the rectangular button, and the camera flashes, and he places the picture of his tonsils inside his jacket pocket and still they're riding, Odile in front, Jack behind, trying to hold the camera and pedal at the same time, and at the streetlight a block away, they stop, and Odile takes the camera back and then grabs the front of Jack's pants and forces it into his underwear and she snaps a picture and Jack says, "Come on, nobody wants

to see that," and Odile laughs and what comes through is an unnatural portrait of his genitalia and Odile shakes the film, waiting for the streetlight to turn green, and then she says, "You could never tell it's you. You know? It's actually pretty impersonal. I wonder why people get so hung up on it. It's actually pretty inconsequential—sex, I mean," and Jack shrugs his shoulders and they ride off again and he watches her as she wedges the photo into her pocket, but it sticks out like a white flag.

"Now what?" Jack asks, and Odile glances over her shoulder and only laughs. At the next stoplight she grabs Jack by his ear and forces her tongue in his mouth and then takes a picture of that. And then a block later she sticks her cold hands down his pants again, and takes a picture of that, her fingers wrapped around his testicles. The camera becomes their accomplice until the film runs out and then they ride over to the twenty-four-hour corporate copy shop where Odile's roommate works, but she is not on duty tonight, and so they place the Polaroids on the glassy surface of the copy machine and begin to assemble a small zine, page after page, eight pictures in all, the final picture being the one of Odile kissing Jack, and they only make ten copies and on the cover of the booklet Odile writes, *ALPHONSE F. IS IN LOVE,* and they leave these ten booklets in odd places all over the neighborhood, placing them under windshield wipers of parked cars, in mailboxes, in the gaps of metal fences. And as they ride on Jack begins to think this: *As a boy, all I ever wanted was this: a life dedicated to art; every idea, every breath an artistic gesture. And here is this girl before me, blowing on her hands to keep warm. And why am I so worried it's not going to last?* But he mentions none of this to Odile and then they return to his apartment once again, faces frozen from the

cold, laughing at each other's runny noses in the teasing way they do. And then again and again they're kissing.

ALPHONSE F.

IS IN LOVE

BEFORE WORK ON THURSDAY.

Odile asks Jack if he wants to go to an art lecture and he asks, "What?" and she says an art lecture and Jack asks, "An art lecture on what?" and Odile only laughs and so he follows her on his bicycle and they end up at a small bookstore off of Milwaukee, and the bookstore is crowded by a serious-looking audience, most of whom are in sports jackets or turtlenecks, and Odile elbows him hard in the side, and Jack looks at her, and then over to where she is glaring, and there is the professor, the one from the gallery, with his white Van Dyke beard, and he is sitting on a folding chair at the front of the audience, and Odile whispers, "I knew he'd be here. This guy, he's like that asshole's favorite art critic. He's got a whole book on Pop Art," and the speaker goes up to the small wooden lectern and opens a tiny red book, and whispering into the microphone he begins to speak. "I'd like to start off with a quote. By Rilke. If I may." And everyone murmurs in agreement at what a great idea that is.

And then the art critic, who has large spectacles and a long face, clears his throat and intones: "No great art has ever been made without the artist having known danger ..." and it's then that Odile begins to boo, and it suddenly becomes clear that that's why they're here, to disrupt this poor art critic's lecture, and Jack grabs her arm, but Odile keeps calling out, "Booooo," and the art critic looks so alarmed, so completely befuddled that someone beside him should be speaking, let alone replying with such nastiness, that he does not know where to look. "Booo!" Odile shouts. "Booo!" And by then,

Odile and Jack are scurrying out, past the crowd of listeners that extends out the door, and they are laughing, and Jack is staring at her, wondering, *Who is this girl?* and then, again, they are almost late for work.

AND THEN WORK IS LIKE THIS.
Meaningless. Boring. Work is marked as the time in between
lungeful kisses.

AFTER WORK ON THURSDAY NIGHT.
They do not talk. They do not look at each other. They ride back to the apartment and undress and climb beneath the crocheted quilt and watch a marathon of *Twin Peaks*, and do it, like that, watching television again, and Jack puts his hands on her breasts from behind, and she does not say anything or move his hands away, and almost by accident he murmurs, "I love you," and she says, "What?" and he says, "Nothing. I just had to sneeze."

AND THAT NEXT MORNING AT SEVEN A.M.

It's Friday and Jack gets another surprise telephone call, this one from his friend Eric who he hasn't spoken to in weeks. Jack sits up in bed and whispers a hello, just as Odile pulls a pillow over her head, and Eric asks, "How would you like to make a couple hundred bucks right now?" and Jack asks, "Doing what?" and Eric says, "We need a substitute teacher. For an art class at my school. The regular art teacher broke her leg and we need someone immediately," and Jack, scratching his nose, says, "What do I know about teaching art to kids?" and Eric barks a laugh and says, "What does anyone know?" and then Eric says, "It's only for a few hours. You can still make it to your job afterward," and Odile pops her head up and asks, "Who is it?" and Jack says, "It's my friend Eric. He wants me to be a substitute art teacher. I don't think I'm going to do it," and Odile smiles, tilting her face up to him, and says, "You should do it," and he says, "Really?" and she says, "Are you kidding me? You should definitely do it," and he says, "I don't know. What if they laugh?" and she says, "What do you have to lose?" trying to convince him, and he asks Eric, picking up the phone again, "Do I have to wear a tie?" and Eric laughs once more and says, "You can pretty much wear whatever you like. It's private school," and Jack asks, "Can I think about it and call you back?" and Eric says, "What? No way," and so Jack says, "Well, I guess okay."

"Okay?" Eric asks, excited.

"Okay," and this is how Jack becomes a substitute teacher. He decides to wear a tie anyway because he is afraid

of how young he looks and it's one of the first questions the students ask and he makes a joke out of it and tells them he's twelve years old. He has a blue tie on, the only one he owns, and there is a room full of fourth graders, most of them white or Mexican or Puerto Rican, a few black kids in the back, staring at him, waiting for him to do something.

And so finally he does.

On that first day he talks about Surrealism. And he has them do self-portraits of themselves as regular household objects. Some girl does a drawing of herself as an ironing board, and a boy with sharp blue eyes makes himself into a bathtub.

And another class, the eighth graders, he describes postmodernism to and has them each make a paper mask of their favorite dead person and there is a chilling number of George Washingtons and Michael Jacksons. When he explains that Michael Jackson is not dead, the three girls who made the Michael Jackson masks tell them that they know and don't care. They just really wanted to make Michael Jackson masks. And then he thinks, *Wow. This might be the job for me.*

AT THE END OF THE SCHOOL DAY.
The principal, a heavyset black woman, peeks her head into the classroom and asks how he liked it, and he says, "I really loved it," and she nods and smiles and says, "What's your next two weeks look like?" and he says, "I think they look pretty good," and she asks if he's interested in returning until Mrs. Epps, the regular art teacher, is back on her feet, and he says, "Yes. Without a doubt," and as he's riding his bicycle home at three p.m., he feels like things are really going to be okay. The city is so clear now; the snow has stopped and everything looks like it's made out of ice. Suddenly the possibilities, the days looping before him in their unpredictable order, with Odile waiting somewhere for him, seem endless.

MEANWHILE.

On Friday afternoon, while Jack is becoming a substitute teacher, Odile rides her bicycle to her former art school downtown and, using her old school ID, she skulks around, up to the ninth floor of the art and design department, and there she asks the student worker at the front desk what classes Professor Wills is teaching this semester, and look at that, she happens to be in luck. He has a Painting Two seminar on Tuesday, Thursday, and Friday, and so Odile waits around until two p.m., when the class is over, and she peeks from behind an old issue of *ArtForum* and she follows him with her eyes as he enters the office and then disappears for a few minutes, collecting his things. And as he puts on his coat and scarf and enters the next available elevator, Odile follows him, eyes cast down, careful not to do anything to get his attention. Then they are out on Michigan Avenue and Odile is following him at a short distance and sees how Professor Wills, with his salt-and-pepper hair and Van Dyke beard, seems to drag his left leg a little, making longer dashes in the slippery snow, and then she follows him across the street and into the warmer dark of a nearby parking garage, Odile moving from shadow to shadow, some twenty, thirty feet back, and it's there, finally, on the third floor of the parking garage, that she sees Professor Wills climb into his modest teal Subaru, Odile looking down at her watch, seeing it is almost three o'clock now. She waits there in the shadows of a monumental SUV, and only after he has backed up, only after he has driven away, does she return to

the street to where she has her bicycle locked up. And then, in her small green notebook, she writes all of this down.

BUT THERE ARE PHONE MESSAGES.

And since Odile hasn't slept at her apartment in a few days, she decides she probably ought to at least stop by again, as she's run out of clothes and clean underwear and needs to shave her armpits. And so she rides back to her place and drags her bicycle up the stairs, cursing a little at the third-floor landing. When she opens the door, she finds a bunch of notes from Isobel and one of them says, *Check phone messages.* And she does, kicking off her boots, still wearing one of Jack's T-shirts—the one of the banana and the donut—and she hits play on the answering machine.

"Hi. It's me. Haven't talked to you in a while. Just want to make sure you're good. Call me when you're free."

A message from Paul, an incongruous tone of concern in his voice.

Must be fighting with his wife.

Fuck him for being married and for pretending to be worried.

She hits the machine again and there is a message from Jeannie, her friend in New York, from the day before.

"Hey, it's Jeannie. Just wondering if you're still coming out. My roommate is definitely moving and I need to know in the next few days. I think it'd be great. Give me a call when you get a chance."

And then the answering machine beeps again and Odile looks up. It's only like eight days away but Odile hasn't talked to Jeannie and still hasn't done anything to get ready to move. She looms over the answering machine and erases all the

messages and then takes a long, hard look at herself, at the apartment around her, at what it is she thinks she's doing. And there are the cardboard boxes she's been collecting the last few months, stuffed into a corner. There is her bedroom and all the things she should be packing or getting rid of, but she hasn't done a thing. She thought she might be able to sell some stuff by having a garage sale. But it's been too cold and snowy out. Why does she always wait until the last minute? What has she even been waiting for? And what will she do about Jack? Because now all she can think of is his meek little laugh. The weird shape of his nipples. His groaning against her neck. Taking a shower together, listening to Nico singing "Chelsea Girls." The last four days where everything has finally made some sense. And why is she so ready to throw this away? Because. Because eventually every relationship she's been in has turned to shit. Eventually she ends up screwing everything up. So maybe it's better to leave now before people's feelings get hurt. Maybe it's better to leave while it's good, before everything goes to crap. And then, like that, it's been decided—in a matter of moments, in less than a minute. And so she walks off to her bedroom to begin to pack.

SO AT THE OFFICE THAT FRIDAY NIGHT.

Odile is dressed all in black and Jack smiles at her as she takes a seat but she only frowns. She leans over, placing her face before his, peeking from behind the cubicle wall, and says, "Listen, I need to tell you something."

"Okay," he says, unsure of the look on her face.

"I can't sleep with you anymore. We can hang out together. But no more fooling around."

Jack feels his face tighten into a rictus of both surprise and disappointment.

"What? What are you talking about?"

"It's just that ... I'm supposed to be leaving in eight days and I dunno. It's too weird already."

"You're leaving?"

"I am."

"You really are?"

"I have to. If I don't go now like I planned, I never will."

"But why do you have to go anywhere? I mean, why do you want to go to New York so bad?"

"Because if the world's going to end in a year, at least I'll be in the middle of it."

"Funny. Why are you really going?"

"I don't know. I already made all these plans. I never follow through with anything, so I think I have to. I like you. I really do. But I don't think I can have anything complicated in my life right now. So if you want to hang out, that's cool, but other than that ..."

"I just don't get it. When did you decide you were leaving?"

"I don't know. A couple months ago. And then my friend Jeannie called yesterday and I dunno. I knew this was going to happen. This is why I didn't want to fool around with you."

Jack sits there stunned, feeling the stiff back of the office chair poking into his spine. He touches his black glasses, feels the weight pressing down against his face. "I don't know what I'm supposed to say here," he mutters.

"Nothing. You don't have to say anything. It's just how it is."

"Well, that's good because I can't think of anything."

"I'm sorry. I tried to be up front about it. I mean, if you still want to hang out before I go, we can. I just can't fool around with you."

She crosses her arms in front of her chest and Jack can still remember the feel of her soft mouth against his.

"I'm sorry to be so weird about this," she says, her eyes going gray.

"Okay, cool. Great. No big deal," he says, feeling his forehead tighten sharply.

"Okay. Good."

"Great."

And then both of them glance away, unsure where to look. The phones go on ringing but the two of them ignore everything.

"We should probably get back to work," Jack says, wanting this uncomfortable moment to end, end, end. And the moment does end, and then there is the feeling that this is the end for the two of them; there is the feeling that this is the end of everything, and the feeling climbs, propulsive, decidedly, into the air. And then that is it. The last four days, some of the best days he's ever had, are now over. And then. Then nothing. Then a kind of informal, intractable despair. Calculator watches are broken later that evening when certain

people punch the restroom walls out of frustration. Young persons who had been sleeping together act like sitting in cubicles beside each other means nothing. And then it does. Means nothing. And there are the ringing telephones. And the office, absent of both furious attraction and longing. Everything slows to gray-green gloom. And it's like nothing interesting has ever happened to anybody.

AFTER WORK THAT FRIDAY NIGHT.

Odile rides home alone at one a.m., feeling more than a little sorry for herself. And then, after heaving her bicycle up the moldy steps and unlocking the front door with a groan, she sees Isobel's shoes are gone, which means she's at Edward's, and so she smiles inwardly and then stands over the answering machine, listening to the messages, hoping that there'll be one from Jack, something telling her how stupid this all is, asking if it's okay if he comes by. But there's only one message and it's from her mother, in her typically sedate voice.

"Hi, Poppy, it's Mom. We're just calling to see if your brother is there with you. He's been gone two days now and we're starting to get worried. If he is there, do you mind giving us a call and letting us know? You can tell him he's not in trouble, we just want to know he's all right. If not, then you can disregard this message. Okay, hope everything is good with you. Talk to you soon."

And then the answering machine beeps, ending the message.

Odile, on a whim, peeks out from behind the blinds at the snow-swept street. She half-expects to see her brother there, staring up, but there is nothing, only the useless footprints of strangers leading nowhere. She turns back and begins to get undressed, pulling her sweater off, unclipping her earrings. She gives her bedroom door a shove, nudging it open with her hip, and there she finds her idiot younger brother sleeping in her bed in his stupid green sleeping bag.

"Ike, what the fuck?" she shouts, waking him up.

He looks groggy. And it appears he's now trying to grow a beard. The bristles look ridiculous on his slim, pallid face.

"What are you doing here?"

"I had to come back. I can't handle being alone at home. Nobody gets me."

"When did you get here?"

"Today, tonight, while you were at work. Isobel said it was okay if I waited."

"Why didn't you call me?"

"Isobel didn't know the number there," he explains.

"Jesus, Ike. You can't stay here. You have to go back."

"Why?"

"Because Mom and Dad are shitting themselves. Did you call them and tell them where you are?"

"No. I called but I didn't tell them where I was. I just said I was all right."

"They are going to have my ass for this. You need to call them and tell them you're coming home tomorrow."

"But you said I could stay. If I called."

"You didn't call."

"I did. After I got here."

"Ike. You have to go home. You can stay tonight, but tomorrow you have to go."

"Why?"

"Because. Because I'm moving in a couple days. And you need to finish school. You're not going to be able to do shit if you don't get a high school degree."

"What do I care?"

"Jesus, Ike. We need to call Mom and Dad right now."

"No way."

"Okay, well, I'm calling then."

"See if I care," he says, sounding just like an eight-year-old.

She grabs the phone and drags it into the bathroom and dials her parents, but of course her mom doesn't answer because she takes a sleeping pill every night. And her father won't pick it up because he doesn't answer the phone past ten p.m. on general principle. But she dials again, and then a third time. And still, no answer. And when she walks back out into her bedroom, she sees Ike is gone. His clothes, his green sleeping bag, all of it. She throws the phone down and runs out into the hall and the front door is partly open, trapped by the snow, and she hurries across the front steps in her socks and looks both ways down the street but all she can see are the avalanched cars and the bored, bald-looking trees.

AND WHO DOES SHE CALL?

But Jack, and says, "Please, please, I need your help," and he says, "You got to be kidding me," and she says, "Please," and he says, "You just broke up with me. Why would I want to help you?" and she says, "Jack; please, this is an emergency, I don't have anyone else I can ask, Isobel is gone and I don't have anyone," and so together, on their bicycles, they traverse the neighborhood at two a.m., looking for her younger brother. They stop in all-night Laundromats, at a copy shop, at a twenty-four-hour record store, the two of them riding up to the establishment's door, Odile leaping off her bike, Jack staying outside, holding the handlebars of her bicycle while she searches inside, watching as she reappears with the same spooky expression on her face.

"What if he killed himself or something?" Odile asks, and Jack shakes his head.

"He's okay. We just have to keep looking."

In and out of diners, and an all-night pharmacy, and a supermarket that's open around the clock, but he is nowhere, there is just no sign of him. And so they decide to split up. Riding past Division and Ashland, Jack gets an idea and hops off his bicycle, locking it to a parking meter, and then he runs down the steps of the Blue Line subway station, and fumbling for his dollar and change, he puts it into the machine and hurries across the dirt-speckled steps to the platform, and at the end of it is a small rectangular wood bench, and on the bench is a boy who must be sixteen or seventeen, a gawky kid, tall, with an irregular-looking Adam's apple and a scruffy

face, but the shape of the eyes, the features are mostly the same, and so Jack walks up to him cautiously and asks, "Are you Ike?" and the boy's eyes go wild at the insinuation, and he grabs his green duffel bag, pulling it close, and Jack smiles, holding out his hand to shake, but the boy gathers up his bags and stands, stepping away, and so Jack says, "We've been looking for you. Me and your sister. Are you okay?"

The kid looks guilty then, his face going a little white, and he asks, "Who the heck are you?"

"I'm Jack," he says, holding out his hand again. "I'm a friend of your sister. We've been riding all over trying to find you. She's really worried."

"Why are you looking for me?"

"Because your sister asked me to."

"Are you having intercourse with her?"

"What?"

"She's a bitch. She'll sleep with anybody. She's like the most selfish person in the world."

"I think she's really worried about you."

"Sure she is. She doesn't care about anybody but herself."

Jack frowns, pushing his glasses up against his face. "How about we go back up to the street and try and find her and then you can talk to her about all of this?"

"No."

"No?"

"No way. I came here because I'm in trouble and I thought she would help me, but no one wants to help me."

"She does want to help you. I mean, you wouldn't believe how worried she is. That's why she called me."

"No. She's just like my folks. All she wants is for me to go back home. She doesn't really care what's going on."

Jack nods, unsure what to say. The kid stares down at the gray steel of the train tracks and mutters, "I'm not cut out

for this kind of life. I should have been a wizard. Or a mage."

"What's a mage?"

"I don't know. A different kind of wizard, I guess. He doesn't need a staff or amulet to perform his magic."

"Oh," Jack says. "There's not a lot of people like that floating around."

But the kid doesn't even smile. "Do you know when we were kids, Odile and me, we used to take a bath together? She's only six years older. We did everything together. Now there's nobody but my weirdo parents in our house. And they don't get me. They're high half the time anyway."

Jack nods, again unsure what he's supposed to say.

"I'm tired of high school," the kid says. "I'm tired of my friends. Everybody keeps telling me how important high school is, to get into college and everything, but it just doesn't interest me. I think I'd like to travel. I'm thinking of maybe joining the navy."

"You are?"

"Yeah, I don't know, I'm afraid to because I'm not tough enough."

"That's all right. Neither am I," Jack admits. "But you could always travel somewhere on your own."

"I know," the kid says. "But that way, in the navy, you'd have all these buddies. It would be exciting, like we were on a mission. I don't know. I don't have friends like that anymore. Nobody likes to do anything. There's nobody I know who likes to do things."

"Me neither," Jack admits. "Except for your sister."

The boy, Ike, nods, smiling for the first time. "We used to pretend to go to the moon. When we were kids. She'd turn the entire basement into the surface of the moon. Or we'd make our own circus. Or a jungle in the backyard. I don't have anybody like that anymore. There's nobody to make-believe

with. Nobody wants to have an adventure."

Jack sighs into the cold, cavernous air. "Your sister does."

"Yeah," he says with a soft tone of resignation. "But just watch. She'll leave you too. She quits everything."

Jack feels the cold air pierce his chest. "It's pretty hard not to like her," he says. "Even when you know you shouldn't." He looks over at the kid and tries to summon a smile. Both of them nod then. Jack fixes his glasses again and then puts a hand on the kid's green duffel bag. "What do you say we go up to the street and see if we can find her? She's going to be really glad to see you."

The kid scratches at his nose and says, "Okay. If you think she's that worried," and Jack nods and helps him with his duffel bag, walking up the sloping steps, pushing through the silver turnstile, climbing up the concrete stairs to the near-empty street.

After a half hour or so of waiting in front of the apartment, Odile finally rides up on her green bicycle, spotting the two people there waiting for her, hopping off, throwing her arms around her brother's neck.

"You scared the hell out of me," she says. "You got to promise not to do that again."

"I won't," Ike says sheepishly. "I'm sorry. I just ... I'm really having a bad year."

"Me too," Odile says.

"Me too," Jack adds, and everybody laughs, but cautiously, their eyes moving back down to their own feet.

In silence then, the three of them stand in the dark, Odile still hugging her brother a moment longer, until she turns and grabs ahold of Jack's ungloved hand.

"I can't believe you found him. You ... you're really amazing."

Jack feels his face getting flush.

"We're gonna head upstairs," she says. "Do you want to come up with?"

The rough stitch of her mitten clutches at his hand.

"I could make some coffee," she says.

"Do you want me to?"

"I don't know. What do you think?"

"I really don't know," he says glumly.

"Then we probably shouldn't."

"Probably not," he says, only wanting her to say, *Yes, yes, yes. Come upstairs with me. Forget the whole thing.*

But she doesn't. She plays with her white hat and says, "Well. Okay. I guess I'll see you on Monday. I owe you one," and Jack nods and says, "Don't mention it," and rides off into the distance, the sound of his bicycle, its rear tire slipping against the snow, the exact sound of his thoughts going dark.

AND THE WEEKEND GOES BY LIKE THIS.

Imagine a toilet flushing down everything important. A gargantuan pile of shit.

SO IN THE OFFICE THAT MONDAY.

Things are still really fractured, really weird. He thinks about saying something to Odile but he doesn't. He pays attention to the phone, types an order with the yellowed keyboard, hangs up the phone, and then answers it again. It goes like this hour after hour until Odile, brushing her bangs with her fingertips, finally leans back and says, "I put my brother on the bus yesterday."

"You did?"

"He wasn't too happy about it."

"I bet."

"He said he liked meeting you, though. He said he thought you were pretty nice."

Jack nods, not saying a word.

"So," she says, sighing, "I'm leaving in like five days."

"Wow," he responds, trying to speak without interest or heat.

"On Saturday. It's weird."

"It is."

"I'm not even packed yet. I was going to try to have a garage sale sometime, but I don't know. I might just end up throwing a lot of stuff out."

"Did you tell Gomez yet?"

"No. I guess I have to tell him. I was afraid if I told him before now, he'd fire me. I mean, I plan on working all the way to Friday. I need all the money I can get."

"So you're not going to tell him until Friday?"

"That's the plan. Do you think he's going to be pissed?"

"Probably."

"What can I do? I guess I can just add him to the list of people who are mad at me."

Jack smiles softly, against his better judgment. "I'm not mad at you."

"You're not?"

"Maybe," he says.

She smiles at him. "So."

"So."

"I was thinking."

"Yeah?"

"I know this is kind of weird but I was thinking of doing something to that professor I had. The bad one. From the gallery. Before I leave on Saturday. You know, like one last act by the great Alphonse F."

"Really?"

"Really. It'd be great if you wanted to come," she says.

"When?"

"I dunno. Tomorrow afternoon. I was thinking of maybe doing something to his car. I figured out where he parks. I was thinking of maybe decorating it. Or gluing stuff to it."

"What were you going to glue to it?"

"I dunno. Household items maybe. I haven't really figured it out. Do you want to come?"

"Really?"

"Really."

"Do you want me to?" he asks.

"I wouldn't have asked if I didn't want you to," she says, and it looks like she's blushing.

"I guess so. I mean, I will, if you want me to."

And she nods, tucking a strand of her dark hair behind her ear. "Okay. We begin our attack tomorrow afternoon at one p.m."

And Jack nods too, watching her perform her vanishing act again.

ON TUESDAY AFTERNOON AT ONE P.M.

Together they lock their bicycles up off of Madison, and Odile lugs two huge paper grocery bags with her, and they sneak into the parking garage, walking row by row by row until they find the professor's car, the teal Subaru, there on the fourth level. Odile has her green hood up and Jack is in his blue hat. And they stare at the car for a moment, standing beside each other in the near dark, the smell of snow and salt melting along the concrete floor, before Odile finally opens up one of the paper bags. They are filled with bunches and bunches of bananas, some bright yellow, some green, some already gone black.

"Bananas?" he asks.

"Bananas. They were on sale so I got like a hundred of them. I thought, because they're really kind of phallic, and also, pretty much the funniest fruit in the world ..."

"What are we supposed to do with them?"

"I don't know. Put them on his car. Like smash them into his windshield or something. Here," and she hands him two bunches, one green and one yellow.

Jack stares down at the bananas and frowns, looking at the second paper bag near Odile's feet. "So what's in the other bag?"

"Some frozen dog shit I found in front of my apartment."

"You brought dog shit? Really?"

"I don't know. Why not?"

"I don't know. That seems a little harsh."

"It's not harsh."

"Well, what about our masks?"

"Oh. Right," and she digs into the pocket of her parka and finds the two ski masks, handing the red one to Jack. He takes it in his hand and looks at it, but does not put it on. Odile already has the black mask over her face, and is smooshing bananas all over the rear windshield.

"Come on," she says. "Let's hurry. He gets out of class at two."

Jack nods but doesn't move. He stands there and watches as Odile heaps the bananas all over the roof and hood of the car. She begins unpeeling a few, smashing them against the cruddy glass of the front windshield.

When she notices Jack still hasn't moved, she looks over at him and frowns. "What? What's wrong?"

"Nothing. I don't know. I guess I don't feel like doing this."

"Come on. It's fun. It's funny. We're striking a defining blow at artistic mediocrity. He's gonna shit his pants."

"No," Jack says, still holding the bananas. "I don't think I want to do this anymore. It's kind of mean."

Odile pulls the black mask off her face. "This guy, you heard him at that gallery. He's everything you're against. He's just this cynical know-it-all ..."

Jack pushes his glasses up against the bridge of his nose and says, "So?"

"So?" she shouts, getting red-faced. "What do you mean, so?"

"I don't know. I'm sorry but I think I'm going to go," he says, handing her back the bunches of unripened bananas. He looks at her again, then down at the bananas, and then slowly he begins to walk away, heading down the angled concrete ramp.

"We're just too similar," she calls out. "That's the problem."

He stops and turns to face her. "We're not similar at all."

"Either way," she says.

"I just don't know why you're moving. Actually, I think it's pretty dumb."

"I told you why. If I don't do it now, I never will. I'll just be some office drone ten years from now, wishing I had done something interesting at least once in my life."

"I just don't get what you think is going to happen there. I don't understand it. What's there that's not here?"

"You wouldn't understand it. You don't like taking chances. You're kind of weak that way."

"What? What are you talking about? I'm not weak."

"You kind of are. You don't like to do anything on your own. And you don't ever finish anything. Like all those tapes in your apartment. I think you like the idea of being an artist more than you actually like making things."

"What? What are you talking about?" He steps toward her.

"You don't do anything interesting on your own," she says, shrugging beneath her green hood. "I'm just stating a fact."

And Jack gets right in her face and says: "Well, at least I don't think I'm something I'm not."

"What's that supposed to mean?"

"You think you're some kind of genius but you work in a crummy little office just like everybody else. You're worse than all those people. At least they don't think they're something special. You. You're just some office drone and you don't even know it."

Odile's eyes go wide. "Okay. Wow. I think we're done talking here."

"Good," he says.

"Good," she repeats. And then: "I think I want my button back now."

"What?"

"The button I made. I'd like it back right now."

And Jack looks down and sees the small black *F* button on his coat. He grabs it, unpins it, and places it in her hand a little too roughly.

"Great," he says, and then walks off, this time as quickly as he can.

At the bottom of the parking garage's steep incline, he finds his bicycle locked next to hers. They seem so happy together, and yet a few moments later, slipping the bike lock into his back pocket, they are soon parted. And then the sight of her green bicycle locked there alone seems particularly sad and ridiculous.

AND THAT NIGHT AT WORK.

The two of them do not talk in the break room before their shift because Odile doesn't show up on time, and when she does arrive it's almost an hour late and Gomez yells at her and it looks like she's going to cry or maybe quit right there but she doesn't. And the two of them, Odile and Jack, sit beside each other in their cubicles, answering their telephones, each waiting for the other to make the first move. But neither of them do. It's too weird at first and neither of them knows what to say. And so they say nothing. Which is a mistake. Because then it is almost ten p.m. before Odile finally concedes. And when she does, she pokes her face into his cubicle angrily.

"I'm not going to play these games with you!" she shouts, though careful of the volume of her voice.

"Okay," he says. "Neither am I. I mean, I don't want to play any games."

"Great. Wonderful," and her head disappears back behind the cubicle wall again.

And he really wants to know what Odile is thinking and so, after a half hour, he leans over and says: "Listen. I'm sorry about what I said. But I really like you and I think it's kind of stupid that you're leaving. I mean ... can we ... I mean ... will you just talk to me?"

But Odile doesn't answer. All he can see is the back of her head, the shape of her dark hair, the ridge of her left ear.

"Because right now it's really weird," he continues. "Maybe we should ... I mean, maybe you think it was all a mistake. Is that what you think?"

"No. Do you?"

"No. But I don't know why you're being so weird."

"I'm not being weird," she says.

"No, it's like you're purposefully trying to be mean or something."

"I'm not. It's just ... It's just really complicated. I really like you, but—" and then she doesn't finish her sentence. "Shit. Gomez is watching."

And Jack looks up and Gomez is standing in the conference room with a half-eaten enchilada, some of it dotting his white shirt, staring at them with a suspicious look.

"If it's that big of a problem ... we can just forget it. It's like no big deal. I mean ... we were just having fun. It's not like it has to mean anything. We can just totally forget it," Jack says, hoping she will immediately, definitively say no. No. No.

But she doesn't.

And he can't see her face; it's obscured by the gray cubicle wall and she's saying in a soft, hurt tone, "Okay. Whatever. If that's what you want."

"What?"

"We'll just, you know, forget all about it. That's great."

And she won't look at him.

And Jack is nodding, not believing what either of them is saying. And his face feels hot and he coughs a little and says, "Okay. Great."

"Great. Your problem is my problem," she says, still not looking at him.

"Okay. Cool."

"I don't think I'm special. I want you to know that," Odile says sharply. "I don't think I'm better than everybody else."

And he nods and his face is really red. He does not know what to say and so he keeps nodding his head and then he watches her face disappear behind the cubicle wall one more

time. And then it's like that the rest of the night. Moment after moment, hour after hour, absolutely quiet, even in the elevator going down.

ON HIS BICYCLE THEN.

And then they are unlocking their bicycles and still not talking. And she is taking off into the snow without saying a word. And Jack does not know what to do and so he follows her at a distance. And she is in her gray skirt and black tights riding her bike toward her apartment and he is thinking of what he can say to her now. And a few moments later her bicycle slips in the snow and she crashes into a parked car and so she begins shouting. He feels embarrassed seeing her shout like that and also guilty having seen it and he knows he is somehow to blame for the way she is standing there in the street screaming. And so he pauses. And then turns away as quickly as he can.

AND SO RETURNING TO HIS APARTMENT
THAT NIGHT AT TWO A.M.

Jack sits on the bed, staring at the dirty sheets, at the subtle indentation of Odile's body, the shape her face once made on the pillow, taking in the scent of her hair, the odor of her body, her toothpaste, her sweat, the particular smell of her clothes still on everything—the sofa cushions, in his mouth, on his face, his fingers, his hands. And he gets up and then stands in the short hall that leads to the parlor and stares at the boxes and boxes of cassette tapes, shoe boxes everywhere stacked tall, filling every corner, placed along every wall, from the front door to the bathroom, and then he pulls his shoes on and begins carrying them out in stacks as high as eight or nine, balancing them against his arms, carrying them out of the apartment and down the hall right over to the trash chute. And he opens the grimy trash chute door, and one by one he slides them through. He does it without thinking, not mad or sad or angry, only feeling like something is finally over, because something *is* over, and Odile has already heard it, and there is no one else in the world he can imagine wanting to share this with, and so it is finally finished, and after he has shoved each box down the chute, all four hundred and some odd minicassettes disappearing through the black square opening, he walks back inside his apartment, opens the bedroom closet, and finds the three gift-wrapped boxes, Elise's Christmas presents, sitting there on the top shelf. He scratches his nose and then grabs the three red and silver boxes, each tied with a bow, and marches down the hallway

again. He opens the trash chute one more time and feeds each of them in—a hair dryer, a box set of CDs, a book by a German writer she loves—and then closes the metal door with a bang. And then he rubs his hands on the knees of his pants and walks back inside his place. He stands there for a full minute, looking at the walls, the floors, the doorways, now uncrowded, now completely bare, years of sunlight on the south-facing wall having etched the outlines of some of the stacks of boxes along the north-facing wall, so that there's still a silhouette, a shadow of an imaginary skyline, and he stands there and looks around and sighs, feeling happy with himself for the moment. And then Jack stares at his answering machine sitting there on the small card table and thinks about recording over Elise's voice message. But he doesn't do that just yet. He will, but not yet. And after that he walks over to his desk and picks up the pencil and goes to work on his screenplay.

ON THAT WEDNESDAY AFTERNOON.

He wakes up and feels his tongue glued to the roof of his mouth because he must have taken too many Xanax and as he's trying to climb out of his bed in a fog, he hears the phone ringing, and he squints and cannot remember where he has left it, and it keeps ringing and ringing and he finally finds it under a pillow and he holds it upside down to the side of his face and says "Hello" a few times before he realizes his mistake, and it's Magdalena, his stepfather David's wife, his stepfather's ex-wife now, and she says, "David wants to see you. He's not feeling so good. He had the operation but now he has an infection and he's not doing so good," and Jack takes down the name of the hospital and his stepfather's room number, then puts the phone back under the pillow again.

And later he washes his face. And tries to comb his hair. And polishes his glasses on the corner of his shirt. And he goes outside and rides through the snow on his bicycle, all the way down Ashland Avenue to the medical district off of Harrison, and there he finds St. Luke's and locks his bicycle up out front, and then enters the lobby, and signs his name, and gets a pass, and then takes the elevator to the fourth floor. And there is his stepfather's room, and there is his stepdad, David, huddled beneath some blue sheets, and it's obvious he has been heavily medicated. His face looks saggy, as if it's made out of wax. There is a morphine drip and the little button to control it is wedged in his stepfather's right hand. And his stepfather's gray-blue eyes are open but he's staring at nothing, just the pink wall really. The left corner of his lip is

white with some drool. And so Jack takes a seat beside him and puts a hand on his stepfather's rounded shoulder.

"David?"

"Ugh."

"David?"

"Hm."

"David? David Goldberg?"

"Ughhh."

"It's Jack. How are you doing?"

"Ughhhhhhhhhhh."

"What happened, David? Are you okay?"

"I'm all fouled up, Jack. They fouled me up."

"Are you resting? Do you want me to come back later?

"No."

"Are you sure?"

"No."

"What's wrong? Are you in pain?"

"Yes. They gave me morphine but it doesn't seem to help too much. I've got an infection. MRSA. It's a staph infection. I got it after they opened it up. Now I got a pretty bad fever and they don't know how long I'll be in here for. I feel like I'm dying."

"Do you want me to leave? I can come back later. Or tomorrow even."

"No."

"Okay, well, I'm just gonna sit here. How's that?"

"Okay."

"Okay. Do you need anything? Do you want some water?"

"Yes."

Jack pours a glass of water and hands it to his stepfather, who is unable to keep his hands still so Jack holds it for him and gives him a small sip. The water runs down his stepfather's chin and wets the front of his blue hospital gown.

"You're not doing so good."

"No. Look at me. Look what they did to me."

"What did they do?"

"They opened me up. And now I'm sick. I've had it. Close the shutters. Good night, Irene."

"You're going to be okay."

"No. They ruined me. I'm all ruined. Magdalena came by and said I look terrible. That's what she said."

"You don't look so bad."

"I'm not going to be alive next New Year's. I know it."

"What? You'll be fine."

"No. This is it. I can tell."

"It's just an infection."

"No. It's the beginning. It's the beginning of the end."

"You'll be out of here in a few days. You got to tough it out."

"No. No, I know it now. Nothing lasts. Nothing lasts."

"Come on, don't say that."

"Why not? It's true."

"Because. You're going to be fine. I know it."

"No, I'm not. You've got to help me, Jack."

"What do you want me to do?"

"Help me."

"How?"

"I don't know. Just help me."

"What do you want me to do?"

"I don't know. I think I want to pray."

"You want to pray?" Jack says, smiling, surprised, having never known his stepdad to be even remotely religious.

"I think so. Can you help me?"

"What do you want me to do?"

"Turn off the lights maybe."

"What lights?"

"The lights. The lights," his stepdad mutters anxiously, pointing at the fluorescent bulbs overhead.

"Okay, okay, I'm turning off the lights." And Jack stands and yanks the switch down, and then the room folds itself into darkness. "Now what?"

"I don't know. Can you help me pray?"

"What? I don't think I know any prayers. We never went to church. Or temple or anything."

"You have to try to help me. Please. I want to pray."

"Okay. What prayer do you want to do?"

"Shhhhhhhhhhhh. Pray," his stepfather says, taking Jack's hand.

David's fingers are warm, much too warm. Jack feels them in his own and he nods quietly and says: "Okay."

"Okay. Close your eyes."

Jack closes his eyes. His stepfather does so as well. There is silence, or an approximation of silence, in the room for a moment, and then David begins whispering something. It is very quiet at first and then it gets a little louder. And then it's a little louder again. He is humming something but Jack does not recognize it at first.

"David, what are you saying?"

"I'm singing."

"What are you singing?"

"'Sitting by My Window.'"

"I don't know that one."

"By the Tinos. It was the first forty-five I ever bought. Sing it with me."

"I don't know it."

"You don't know it?"

"No."

"Okay. How about 'Stormy Weather'?"

"'Stormy Weather'?"

"'Stormy Weather,'" his stepfather repeats. "Do you know it?"

"I guess. You want me to sing it with you?"

"Yes. Sing it."

"Okay," Jack says, trying to remember some of the words.

His stepfather begins: *"Can't go on ... everything I have is gone ..."*

And then Jack murmurs along, *"Stormy weather ... since my man and me ain't together ..."* his voice moving together with his stepfather's.

David smiles happily, hearing Jack sing, forgetting the rest of the words. He nods a little to himself, his gray-blue eyes losing their focus then. Jack looks over at his stepdad and frowns.

"David?"

"Hm?"

"I'm gonna go now. I'll let you rest. You're gonna be all right. I'll be back tomorrow. Okay?"

"No."

"No. You need to rest. I'll be back tomorrow."

"Okay."

"Okay? I'll stop by tomorrow. Same time. How's that sound?"

"Okay."

"Okay?"

"Thanks, Jack. You're a good kid. I liked you the moment I met you."

Jack laughs and kisses his stepfather's blue-veined hand and walks out into the hallway. Everything outside of the room seems to be at odd angles. And then he is moving down the hall, quicker than he thinks he ought to, toward a destination he does not know or fully understand, his wet shoes making accusatory sounds against the dullness of the multicolored tiles.

AND HE RIDES TO ODILE'S APARTMENT.

Jack rides up on his blue ten-speed bicycle, not expecting to find her there in front of her apartment building, but there she is, in her pink wool mittens, with her green hood lowered over her ears, and she has a small card table setup, beside which is pretty much everything she owns: her bicycle, a boom box, stacks and stacks of books, all of which have pink price tags on them. A garage sale without the garage, right in the middle of the snow. And there on the front of the card table is a small sign Odile has made, which announces: *Garage Sale. Hooray.* Jack looks at the sign and smiles and then he looks up at Odile. At that moment, Odile has a box full of thrift-store clothes which she is trying to close up with a roll of packing tape, but it doesn't look like it's going so well.

"Did you sell anything?"

Odile peers up at him with a frustrated smile. "No. Well, just one thing. This big white penis-shaped lamp I made a few years ago in a sculpture class."

"Good for you."

"Yeah. Good for me," she says, and fixes a pink price tag that has fallen from an old peacoat.

"I came by to tell you something."

She peeks from under the cover of her green hood and says, "You did?" a little fearfully.

"I did."

"Okay."

"I was thinking about it and it turns out you were wrong about a few things."

"Like what?"

And here he realizes he does not know how to say what he's thinking. He wants to say: *First of all, you were wrong about pop music. And art and all of pop culture. And all kinds of things. Because all of it matters. Even if it is awful. Everybody knows all the bad movies and the bad songs on the radio. Because it's the only thing anybody has in common anymore. It's all anybody has. So you were wrong about that and you were wrong about us and you were wrong about me,* but he doesn't actually say any of this out loud. He looks at her, at the soft shape of her face, her eyes, and tries to get his words straight.

"Well?" she asks, and he just stands there and decides not to say anything.

Then he murmurs, "I dunno. I thought you ought to know you were wrong about some things, but now I don't know what they are."

She looks at him and smirks. "Wow. You rode all the way over here to tell me that?"

"I guess so," he says, picking up one of the old paperbacks she's trying to sell, some sci-fi thing. He puts the book down and sees the bizarro comic book Odile discovered at some other garage sale, *Abstract Adventures in Weirdo World*.

"You're selling this comic book?"

"I'm taking a bus out to New York so I don't have a lot of room for anything," she explains.

"Oh." And he picks up the comic, flips a few pages, and then sets it back down. Beside the comic book, placed next to some of her drawings she's trying to sell—one of a hippo, another one of an Eskimo—is her small green notepad. Her idea notebook. He holds it up before her, more than a little surprised.

"You're selling this too? What about all your ideas in here?"

She only frowns.

He flips to a page and says, "What about handing out candy at a bus stop? Or ..." and he flips again. "What about dressing up like a parrot for a day?"

"I don't know. I thought when I got to New York, I could come up with some new ideas."

"How much are you selling it for?"

"What?"

"How much are you selling it for?"

"Really?"

"Sure, why not?"

"I don't know," she says. "A buck?"

Jack reaches for his gray wallet, finds it in his back pocket, opens it up, unfolds a dollar, and then places it in her right pink mitten. He then slips the green notepad into his jacket and glances away, putting his left foot down on the left bicycle pedal.

"So you're really leaving, huh?"

Odile nods, staring at him for a moment, and then turning away. "I'm scared," she says. "I wish somebody I knew was going to be there too."

"What about your friend Jeannie?"

"She's great but I really don't know her all that well." And then she says, "I kind of wish you were coming."

"Yeah." He knows that even in one million years it would never happen. "So what about our art movement?" he asks, not really smiling.

"Who, us?"

"Yeah."

Odile frowns a little, her cheeks looking red. "I guess it's over. Eventually, I guess, they always come to an end. Like the Situationists. Or Surrealism. And then something new always starts."

"Yeah. I guess," he says, beginning to feel the stiltedness

again, and the cold. "Well, I'll probably see you at work in a few hours then."

"Sure," she says, slipping the dollar bill into her coat. "Thanks. For buying something, I mean."

"Sure." And he pushes his glasses up against his face before he sets his other foot on the pedal.

And then she says his name and the way it sounds is so polite, so small, like they are strangers all over again. "Jack?"

"Yep?"

"If I didn't know you, I'd probably never have gone."

"What?"

"If we never met, I'd probably be working the same job the rest of my life."

"Why's that?"

"Because no one's ever taken me seriously before. And you did. So, well, I don't know. You know."

"Some compliment. Look what it gets me."

"It's true. I don't think I'd ever have the guts if I hadn't met you."

"Okay," he says. "Thanks. I mean, it'll be good to have a friend in New York. Whenever I want to be surrounded by assholes."

Odile smiles, looking at him again.

"Okay. See you later," he says.

"Bye," she says, and then she is looking down at her roll of packing tape. And the sun is in her hair and then it is like they have never even met.

AND AS HE RIDES.

He thinks about what he will tell her before they say goodbye. He imagines he will kiss her softly once more on the mouth, then on the cheek, and say good luck with everything, and then watch her walk off, fading directly into the distance. And as he's pedaling, he is so involved thinking about these various goodbye scenarios that he's almost hit by a car again. He swerves out of the way of a gray sedan and a delivery truck beeps at him, and so he ends up riding onto the sidewalk. And a dog barks at him from the end of its leash and he thinks about recording it and then he remembers his tape recorder is gone. So are all of his tapes. And as he rides he listens to the sounds of the city, for the first time in as long as he can remember, without recording any of it. And it all sounds so magnetic, so different. It all sounds so new. And who does he have to thank for that?

AND THAT NIGHT. WEDNESDAY NIGHT.

When he comes into work, Odile is not there. And she does not march in twenty minutes late. An hour goes by, then two, and Jack begins to realize she is not coming. Not at all. And the way her cubicle looks, with her not in it, the sight of her black office chair not teetering around and around, the drone of her unanswered telephone, the absence of her shadow on the gray carpeted floor, all gives Jack the feeling that the office walls are made of paper, that the office, without her, is just pretend.

ON THURSDAY NIGHT.

Odile is not at the office again. Nothing. Nada. Zip. There are no odd questions, no weird suggestions, no excited pantomimes from the cubicle next to his. Only work and the ringing telephone and the occasional off-remembrance: sniffing White-Out, an elevator of silver balloons, riding on a bus beneath a white sheet, touching someone else's hand.

ON FRIDAY EVENING AT FIVE P.M.

He takes the elevator to the thirty-fifth floor, keeping his fingers crossed, but there is only a small Hispanic man with a black mustache sitting at Odile's desk. And then it's obvious. She is really gone. She has really quit. She is not coming back. That's all. That's it. Like that, Odile has disappeared: back into the unfriendly lights of the modern metropolis, just some other half-dreamt thought, a poorly constructed memory.

What went wrong? What sort of mess is this life anyways? he thinks.

Riding back to his apartment at one a.m., he sees a girl with a brown scarf riding a bicycle and he thinks it might be her but he knows it isn't. Here he had this whole idea of what was going to happen and it didn't happen and why didn't it happen? He looks around the city but still doesn't know the answer.

Back at his apartment, he leafs through Odile's small green notebook, her wild, loopy handwriting, reading over her ideas for prospective projects, as if somewhere between the scuffed covers there will be an answer waiting for him. But there are only a few amateurish drawings and a half-dozen half-developed ideas for art projects that they've already done, ideas that are already completed. And he stares at the way she dots her "i's" with empty dots and the shape of her "k's" like kites and then wonders what, if any of it, lasts. Does anything ever last?

What lasts?

What lasts?

What lasts?
What lasts?
What lasts?

And so he stares for an hour or so at all her notes, at the poorly sketched drawings for an art movement that has now come to an end, and realizes how there are all these moments, moments like just this one, there are all these moments, and how everyone lives their lives in these short, all-too-short moments. There are all these moments and what's so interesting, what makes them beautiful, is the fact that none of them last.

ON SATURDAY THEN.

He does not know why but he rides his bicycle by her apartment that afternoon, hoping, thinking maybe by coincidence he will see her, but no. There's nothing but the quiet-looking apartment buildings and the blemished snow gathering in small white hills, wetting the black tires of his bicycle. And then he rides around for a while, thinking of spring, mistaking a crocus for a small purple bird. But it is a crocus. It's small and purple and it's pushing its way up out of the snow.

A MONTH LATER RIDING HOME FROM SUBSTITUTE TEACHING.

Blue tie loosened around his neck, the top button of his shirt undone, Jack thinks about the pop quiz he gave in a history class, asking what instrument Miles Davis played. Only one kid, a black girl with braces, got it right. He smiles to himself and looks up at the stoplight on Milwaukee Avenue and sees a faded silver mark etched on a bus stop sign and beneath it two familiar words, almost indecipherable now:

HELLO JACK

And when the stoplight agrees, turning green, he rides on, smiling to himself, thinking of her and then: *At least there's something. At least there's that.*

There are scribbled notes like this one—secret messages to someone named Jack, nearly unnoticeable declarations— on stop signs, on mailboxes, on garbage cans—still visible all over the city. And so.

DOWN UNDER THE MANHATTAN BRIDGE
OVERPASS ONE MONTH AFTER.

Odile finds herself staring at an empty concrete wall before she sneaks the silver paint pen from her pocket and scrawls a scary profile of Alphonse F., and beneath it she writes these words, almost human-sized:

DON'T. STOP. NOW.

And then she is hurrying away, peeking over her shoulder, skulking off.

IN THE AWFUL FILM VERSION OF THIS BOOK.

In the awful film version of this book: Odile will be played by an unknown actress with a slight resemblance to the singer France Gall. Jack will be portrayed by an actor who happens to be a little too thin. Other than that, their performances will be excellent. At the end of the film, they will run off together, hand in hand, and board a steamship to North Africa. It will be with her beauty and his natural acting that the film will win all the awards and make the public, once again, gaze at each other with a look like love.

Dedicated to Koren + Raymond Queneau + Jean-Luc Godard

With sincere admiration for:
Cody Hudson and Todd Baxter. Heaven is pals.

Many thanks to: Lulu + Nico, Johnny Temple, Aaron Petrovich, Dan Sinker, Mickey Hess, James Vickery, Maria Massie, Sylvie Rabineau, and the Columbia College Fiction Writing Department.

Theme music: No Age, The Duchess and the Duke, Scotland Yard Gospel Choir, Mannequin Men, Smith Westerns, Hunx and His Punx.